Mother

Photographs by

Judy Olausen

Introduction by
Karin Winegar

Design by
Pentagram

VIKING STUDIO

VIKING STUDIO

Published by the Penguin Group

Penguin Putnam Inc., 375 Hudson Street,

New York, New York 10014, U.S.A.

Penguin Books Ltd, 27 Wrights Lane,

London W8 5TZ, England

Penguin Books Australia Ltd, Ringwood,

Victoria, Australia

Penguin Books Canada Ltd, 10 Alcorn Avenue,

Toronto, Ontario, Canada M4V 3B2

Penguin Books (N.Z.) Ltd, 182-190 Wairau Road,

Auckland 10, New Zealand

Penguin Books Ltd, Registered Offices:

Harmondsworth, Middlesex, England

First published in the United States of America by Penguin Studio 1996

This paperback edition published 2000

1 3 5 7 9 10 8 6 4 2

ISBN 0-14-026362-4

CIP data available

Printed in Japan

Set in Engravers' Old Style

Designed by Pentagram

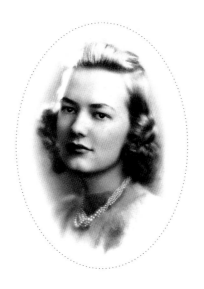

*This book is dedicated to Vivian Olausen,
mother, soul mate*

AS A PHOTOJOURNALIST, I AM A CHRONICLER. THAT'S MY JOB," SAYS JUDY OLAUSEN.

"I wanted to tell the story of what it was like to be a woman in the 1950s. A woman had virtually no career opportunities, except perhaps as a secretary or a nurse. I wanted younger women to see how far we've come—and to see that we didn't always have the options we have now." ❧ So Judy put her 74-year-old mother, Vivian, on her hands and knees on the harvest gold shag rug in front of Vivian's avocado-colored sofa in her split-level suburban rambler, balanced a kidney-shaped sheet of glass on her back and turned her into a coffee table. ❧ For "Mother as Roadkill," Judy posted two friends to halt traffic on a stretch of road near her weekend cabin on Lake Minnetonka, Minnesota, west of the Twin Cities. They waited for the golden late afternoon light, then Vivian dutifully keeled over on the tarmac. ❧ "And all the neighbors were standing behind the bushes watching and drinking beer and whispering," said Judy. "They couldn't understand what we were doing, and a jogger came by and said, 'Well, I know she's not dead—I saw her move!'" ❧ Four years in the making, *Mother* is Judy's vision of the not-so-perfect fifties and a legacy for younger women who escaped a decade that believed an Mrs. was a

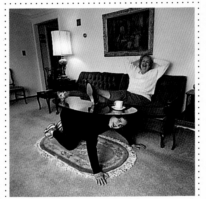

woman's highest possible degree. ❧ "People today have this idea that the fifties were carefree," Judy says. "This is because people stayed on the surface more; they never 'shared' or talked about their private lives. People kept their problems to themselves and just pretended they didn't see or hear anything wrong with the world. But we all paid a price for that silence." ❧ Beneath the gold-flecked Formica veneer, thousands of fifties housewives hit the mid-afternoon gin bottle or loaded up on "mother's little helpers": Valium and Miltown. Isolated at home with the kids while their husbands went to the office, they were quietly, or not so quietly, depressed. ❧ Olausen set out to depict an era in which women were commodified as domestic geishas, as sexpots with cookpots, as something not quite human. "*Mother* contains a very serious message about women being silenced," Judy explains. "That was really an issue in the fifties." ❧ The image that served as a springboard for the project was "Mother as Angel," which Judy created for a local gallery show on the subject of mothers. "I chose to photograph my mother as an angel because she's so kind and loving," says Judy, "She literally is an angel. And I decided

to use a cheap costume rather than a more elaborate one because the kitsch would make it funnier. ❧ "I was shocked to discover what an outstanding model my mother was. I had never looked at her as a model before—only as my mother. But I realized that she has what photographers call a 'rubber face'—tremendous control over her facial expressions and the ability to convey any and all human emotion." ❧ Judy had been thinking about creating a series on women who were mothers during the 1950s and the realization that her own mother was a fantastic actress who might be able to help her tell that story was perhaps her biggest break. "I wasn't certain that my mother would want to do it, but I thought she probably would," Judy recalls. "We're very close—best friends—and enjoy spending time together. When I told her about my ideas, she gave me an enthusiastic 'yes.'" ❧ As the series developed, production included everyone from stylists and location scouts to animal trainers, seamstresses, prop builders

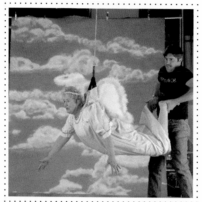

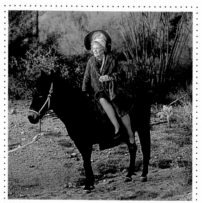

and photographic assistants, but the angel shot was entirely a family affair. Judy's brother Doug, a salesman, is seen hoisting Vivian's feet while her brother Dave, a packaging graphics designer, was off-camera heaving at the mountain-climbing rope that suspended Vivian in midair. And Dave's wife, Cathy, served as mother-handler, bringing Vivian snacks. ❧ By the series' end, Judy rented a taxidermied stork, a ten-foot stuffed grizzly bear, ape suits, junked cars, and half-ton bales of rags. She borrowed manacles from a local S&M torture chamber, purchased aprons by the bagful from vintage clothing dealers and sewed a mock prison uniform. ❧ Vivian was flown, shorn, set on fire, squeezed into bald caps, tied to the roof of a Plymouth Volaré, and strapped under a boulder. The images were made in Vivian's home, in the basement of Judy's studio, at Judy's 1922 lake cabin in the Minnesota north woods, and in a succession of what Judy calls "little old lady houses." ❧ For "Mother as the Virgin Mary," Vivian and Judy flew to Arizona to shoot Vivian sidesaddle in the desert. The production was planned over the phone and things turned out to be not quite as expected. "I ordered a mule and got a donkey—tooo biiigggg!" Judy wails. ❧ Judy Olausen's home/studio is a spacious, three-storey brick building, which she shares with her husband, Brian Sundstrom, a manager at the Minneapolis post office. A one-time brothel and former railroad hotel, the renovation won her a *Metropolitan Home* design award. ❧ Judy grew up in Wayzata, a suburb of Minneapolis, in what she describes in her rapid, stream-of-consciousness speech as "an idyllic childhood, no danger, after breakfast ran wild through the woods climbing apple trees, would come home for lunch, off again

with skinned knees, grabbing horses in fields and trying to ride bareback. This childhood has disappeared; you can't have a childhood like that anymore." She still spends some nights at her mother's home because she likes to hear birdsong in the morning. ❧ "She used to run barefoot in her nightgown through the woods to her girlfriend's house along an old cowpath," says Vivian. "She was always sweet and good and minded, and she's the same way now. I've never been mad at Judy one time; never, never. She always tried to please everybody, and she still does. Yeah, she's been a winner." ❧ Vivian Olausen was "the perfect pulling-the-apple-pie-out-of-the-oven mother, a stay-at-home, loving, patient mother. She still is," says Judy, whose father, George Olausen, general manager for an oil company's real estate, died more than a dozen years ago. "I thought everyone was like me—I thought everyone had a happy time with their mother. When I found out many didn't, it was a shock! ❧ "She nagged like all mothers do," Judy confesses. "I actually did hear 'wear your good underwear in case you're hit by a bus and have to go to the hospital.'" ❧ As a child of the fifties, Judy's adult life followed a much different pattern than her mother's. She attended the University of Minnesota intending to major in architecture but switched after sampling a photojournalism class when one of her architecture classes was full. Vivian

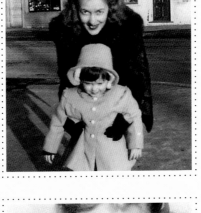

had interrupted her education to marry and raise children, while Judy delayed marriage, attained two bachelor's degrees (in art and photojournalism), and then joined the Minneapolis *Star Tribune* in 1970. ❧ On a Cowles Foundation arts fellowship in 1979, Judy photographed the movers and shakers in the New York art scene, creating portraits of everyone from philanthropist Paul Mellon to Andy Warhol, Frank Stella and Robert Rauschenberg. She became a full-time freelancer in 1988 and went on to photograph performance artist Laurie Anderson, designers Charles and Ray Eames, and Stanley Marsh III, who plants Cadillacs nose down on his Texas estate known as the Cadillac Ranch. She spends her vacations working—in Brazil, Czechoslovakia, Tasmania, Ireland, the Seychelles—documenting a wide range of subjects including opal buyers, survivors of the Titanic, the lives of monkeys and insects, and centenarians. ❧ In 1981, Viktor Hasselblad Aktiebolag camera company named her among the top ten photographers in the world. ❧ She currently alternates the photographing of CEO portraits and annual reports for such clients as Herman Miller and Exxon with projects that have included trips to England to photograph novelist Barbara Cartland, Prince Charles and Princess Diana, and to Japan to document traditional papermaking methods. ❧ In those rare moments when she is not working, Judy

and her mother hit garage and estate sales, a source of props for the "Mother" photographs and for antique furniture and dishes for Judy's lake cabin kitchen. ❧ "We go at least once a week, we have a blast!" says Vivian. "One time we had so much junk in Judy's little Honda that we had to drive home with my head out the window." ❧ As much a product of her own times as her daughter, Vivian Olausen is the daughter of Norwegian immigrants. Her father left Norway at age 14 and met and married her mother in Minnesota. Vivian was raised in Minneapolis, and attended business school while working at Sears for 25 cents an hour opening returned packages. As a working girl, she saved enough to buy herself the great luxuries of that time—a $15 fur coat and a console radio that she still uses. She met George Olausen on a blind date, married him in 1942 and, at the age of 24, became a full-time housewife and mother. ❧ Still a woman of her era, Vivian's vision of the lot of women in the fifties is far less grim than her daughter's. ❧ "I just stayed home and monkeyed around the house," she remembers. "We did a lot of entertaining, but I stayed right here. We played games in the yard with relatives; played charades, poker and hearts, sat around a hexagon card table with slots for coins. We didn't wear slacks, always skirts and blouses and girdles and stockings and lots of culottes with cuffs. And everybody drank in those days: Manhattans and Alexanders with ice cream." ❧ Vivian raised three children largely alone, relying

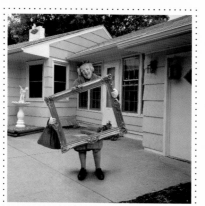

on the bible of the Baby Boom age, *Dr. Spock's Baby Book*. ❧ "After I had Doug I followed Dr. Spock word for word," she says. "Wake up the kid every couple of hours and feed him, it said. Dr. Spock was big on schedules." ❧ Like many fifties fathers, her husband George was rarely home; his job kept him traveling a nine-state circuit. This left Vivian as daily provider. She bought margarine by the case, eggs by the crate, and every Sunday, after services at Oak Knoll Lutheran Church, Vivian says, "I had a roast with carrots and onions and peeled potatoes swimming in grease with lots of gravy and, for dessert, either a homemade cake or pie." ❧ Being a housewife and full-time mother with father in absentia was simply the way everybody did it, explains Vivian, who still gets together with her gang of high school girlfriends, "the Demure Debs," once a month. ❧ In retrospect, says Vivian, "I was really happy. Delirious. I didn't know any better." ❧ Daughter Judy has quite different memories: she saw women erased by a docile conformity that she herself rejects. As her image "House Wife" shows, the existence of a fifties woman "revolved around her house, and she sort of became it. She had no other life, she was literally a house-wife." ❧ In the post-war period, Americans settled in for the fifties with a newly minted battalion of washing machines, vacuum cleaners and percolators and went into a frenzy of housecleaning and decorating with a domestic armamentarium that ranged from Air Wick to Zud Rust Remover. ❧ A woman's place in

the fifties was in that house, and it was her nature to be there, according to such experts as *Good Housekeeping,* which declared "woman's real character…springs from the fact that nature had made her what scientists call womb-centered….Simply stated it means the hallmark of real femininity is altruism defined as regard for and devotion to the interests of others" (*Good Housekeeping*, June 1960). It was a decade that meant "a lot of work!" concedes Vivian, who still lives in the home she and her late husband helped build in the fifties. "Every kind of work; no box cakes, we made everything from scratch. I did a lot of canning: peaches, pears, plums, and apricots which you don't hardly even see in the stores anymore. I used to pay $3 a lug for apricots. And I waited for the Colorado peaches; they were huge, you had to put them up in wide-mouth jars." For Vivian and many other women, Tuesday was always ironing day, Friday was

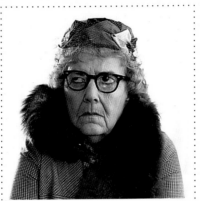

always cleaning day. And she sewed the bulk of her children's clothing: "I don't know how many shirtwaists I made for Judy, like 18, they are so easy to whip up. And one time I took these beautiful iridescent blue curtains and made her a dressy dress." The "Mother" photographs span an innocent who walks on water, a chronic optimist who waits for rain in the desert, and a compliant wife who tried to be lover, maid and cook; someone who lived the fiction of progess. This false sense of progress is the subtext of the "Mother Going Nowhere" sequence in which Vivian/Mother is seen climbing illusory stairs. (Judy dedicates these images to Amy Arntson, who created this "trick" staircase, and opthamologist Aedelbert Ames, Jr., who did breakthrough work on optical illusion.) "Her whole life has been an illusion and she discovers that the stairs are an illusion as well," Judy explains. Fur was the rage of the age, as shown in "Mother in Camouflage," an eye-popping welter of leopard spots from Mother's head to her toes. The fur business boomed in the fifties, as every woman seemed to covet a fur, whether squirrel or seal, Persian lamb or mink. The cost to animals, however, was horrendous. "Nature was a big theme in the design of household ornaments, but always reduced to a cartoon, low-slinking panthers and leopards, dancing swans and flamingos," says Judy. "I view the fifties as the time of our greatest detachment from nature, born out of ignorance." "Mother with Thorns and Turkey" sends up the wholesome light, composition and balance of a Norman Rockwell *Saturday Evening Post* cover illustration—and undercuts it with a crown of thorns. Other images focus on the hyperscrupulousness of housekeeping, the rigorous standards of dress and demeanor, the reduction of women to their relationships to husbands and children, the price of beauty. "Mother as Kitty Valet" represents the unspoken fifties' mandates for women of perpetual cheerfulness and overdressing, Judy explains. "It seemed like Mom had an apron for every task. And women wore heels; good shoes in the house! You won't

catch me wearing heels at home." ❧ The fifties saw Americans switch from saving to spending, from cities to suburbs, from producing to consuming. It was the rise of a new "ism"—consumerism. Shopping became our national religion, as shown in "Mother Goes to Market" with its overtones of mink-coated marketplace martyrdom. The cross-toting Vivian's grocery cart is heaped with cleaning supplies because "Mother can't buy anything fun, anything for herself, of course," says Judy. ❧ "White Death," in which Mother pushes a platter of store-bought sweets, recalls the decade in which Americans for the first time began to savor such mass-produced synthetic snacks as Twinkies, Hostess Cupcakes and Kool-Aid, with no knowledge of the health consequences. ❧ The triumvirate of God, mother and apple pie went largely unchallenged in the fifties, but as indicated in "Mother, Early Sunday Morning," for many people, it was an automaton's religion. ❧ Says Judy: "The fifties woman was not supposed to have any opinions of her own. She lived a very regimented life filled with rules and regulations that were not her own. She went to church like clockwork, as did almost everyone on her block, in her town and city. She didn't ask why. My mother was not a religious person, but we all went to church nonetheless—to do anything else was unthinkable." ❧ And what did all this cheerfulness, cleanliness and capitulation get her? ❧ "Mother as Doormat," "Domestic Hoofer,"

"Mother with Thorns and Turkey" and "Life Sentence" depict the results—endless chores and little respect. ❧ "In a kitschy house full of bad taste and racist knickknacks, the wife lets you wipe your feet on her and then she thanks you and wishes you a nice day," says Judy. ❧ The fifties were the height of the Baby Boom and pregnancy was epidemic, yet women had as little control over their bodies as they did anything else. The photograph "Return to Sender"—in which Mother hides from the Stork's unexpected delivery—evokes the lack of birth control. The Pill was not available until 1960, and other methods were fallible, messy, embarrassing or simply beyond the ability of most women to obtain. ❧ The price of full-time, early motherhood included curtailed educations: the percent of women college students declined almost 15 percent from 1920 to the mid-fifties, when only four out of ten women who entered college planned to go into an occupation. What followed was a lack of marketable job skills, making women even more vulnerable when divorce rates tripled during the sixties (*The Fifties: A Woman's Oral History*, Brett Harvey, HarperPerennial, 1993). ❧ For Judy, the image that is the most menacing is "Don't Look Back," which is part homage to the plastic monsters of cheap Japanese horror flicks and part commentary on the ominous fate that awaited many of the career housewives of the fifties. ❧ "That big spider—to me that's the sixties coming, and her husband is going to leave her and go off with some

younger woman and the housewife has no job skills," Judy explains. "The fifties was the calm before the storm of the sixties." 🐦 As the three muffled monkeys in "Keeper of the Family Secrets" and the excessively toothy mother grimacing in "Mother Puts on a Happy Face" demonstrate, mother stood for suppression and pretense—the essence of the decade. 🐦 "It was 'Father Knows Best' and 'Leave It To Beaver' and you had to put on a happy face even though everything was falling apart, Dad was drinking, people were arguing," she says. "There was this emphasis on being normal, but underneath it was a horrible tension. 🐦 "We only had conversations about nice things—we never talked about real problems. And so we became very adept in the fifties at a kind of glossy conversational style with no meaning or depth. If you have ever had to have a conversation like this over some period of time, it is easy to understand why people in the fifties were filled with a terrible kind of anxiety. Keeping up appearances is a lot of work." 🐦 The cost to many women of the fifties was impaired mental and physical health: while some women took to tranquilizers, others were given dexedrine and other stimulants to have enough energy to get through the day. Often lonely, routinely financially disenfranchised, women's self-esteem suffered as never before. 🐦 The impact could also be seen in a whole generation of daughters,

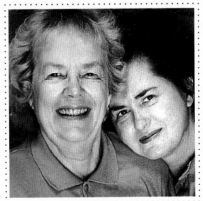

many of whom, like Judy, were determined to have more options than a Spic and Span house. 🐦 "The central theme of the photographs is that a woman must have the right to control her own destiny—whether it's a career in the home or out of it doesn't matter, but it's important for a woman to have choices," said Judy. "For me, being a grown woman in the fifties would have been a nightmare." 🐦 The "Mother" series, like the decade, is a surreal synthesis of the grotesque, the innocent and the goofy, although Judy is quick to point out that it is society in general to which she is holding a mirror, not her own mother. 🐦 "Some people say that these photographs are disrespectful toward my mother, but she is just playing a part—she's acting! Luckily for me, my mother turns out to be one of the most remarkable actresses I have ever worked with. Her range of expressions is stunning. This is a terrific role for her and I can't think of a better tribute for Mother than to put her on museum walls, where I believe she will be some day soon." 🐦 And the loving collaboration of two women who experienced a decade very differently has only deepened a rare relationship. 🐦 "People watching us do these things think I'm being tortured by an oddball," says Vivian. "But we laugh our heads off. We're closer than bark on a tree." 🐦 "We're just best pals, I guess," says Judy. —*Karin Winegar*

House
Wife

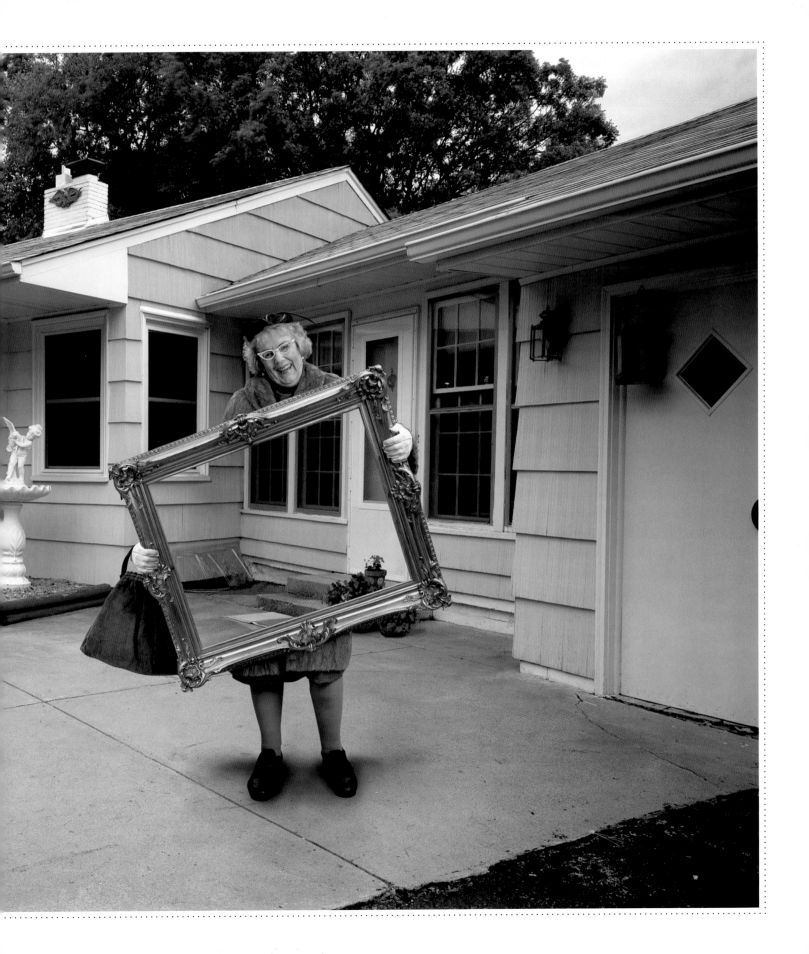

Domestic
Hoofer

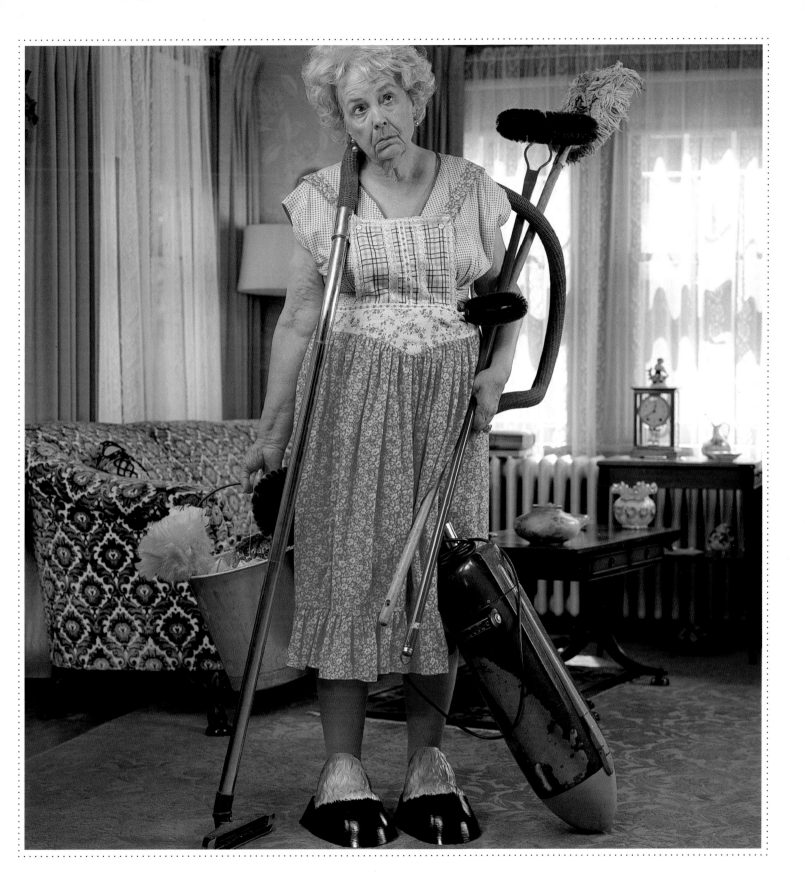

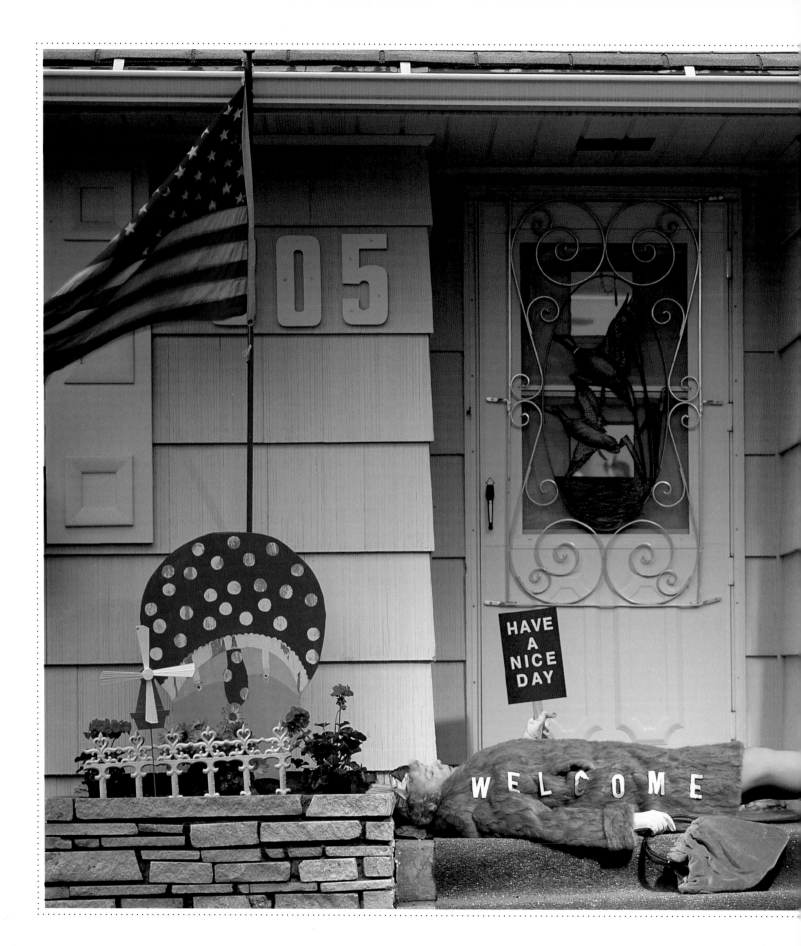

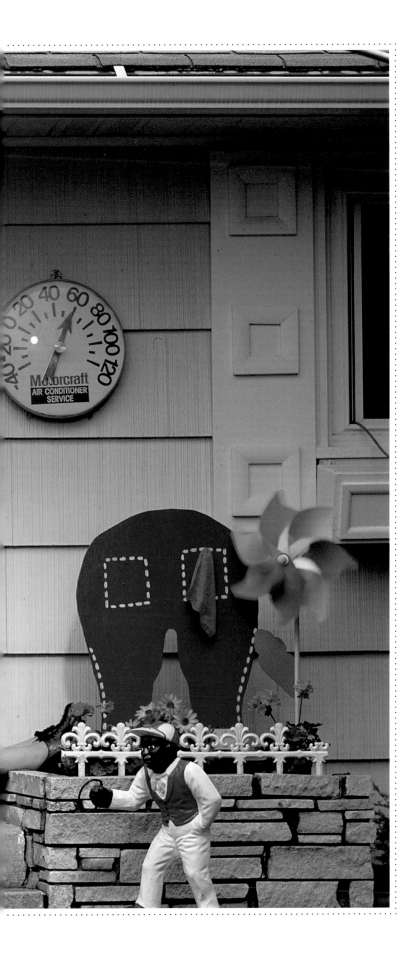

Mother as
Doormat

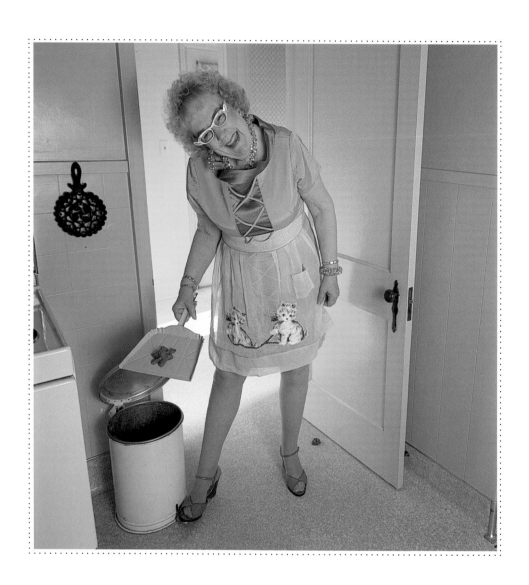

Mother as
 Kitty Valet

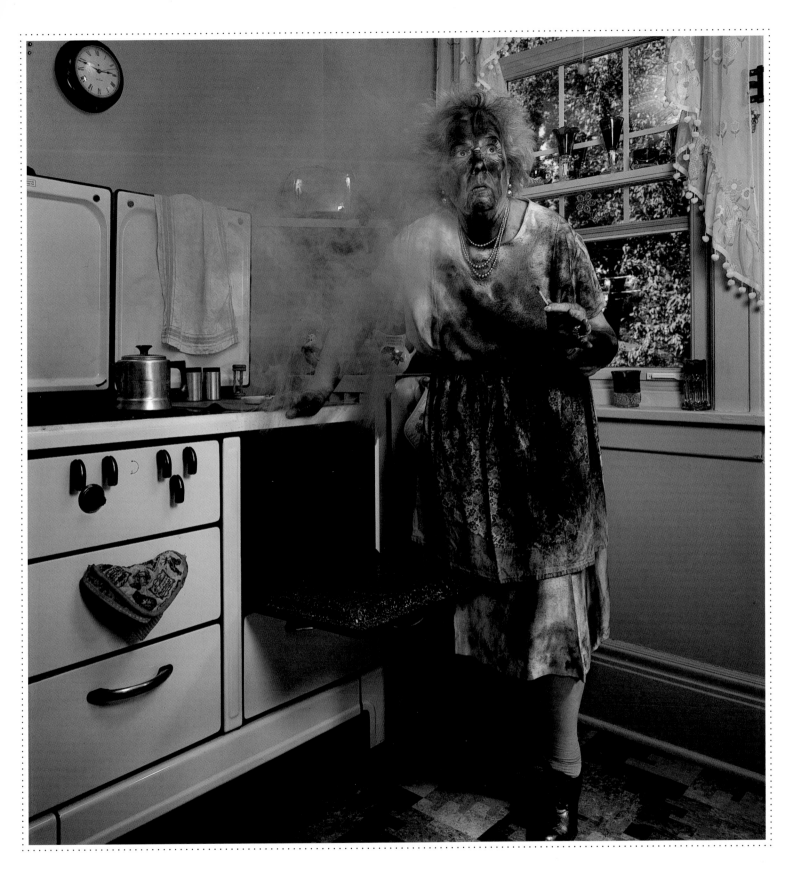

The Joy
of Cooking

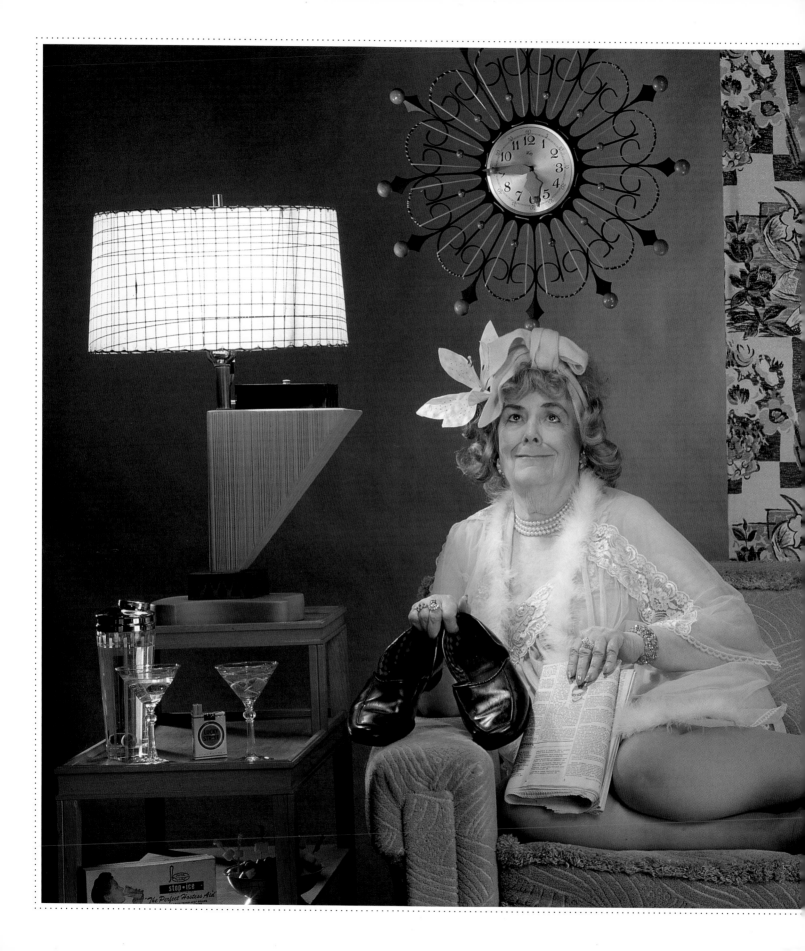

The Good
Wife

Attack of
The Rug Rats

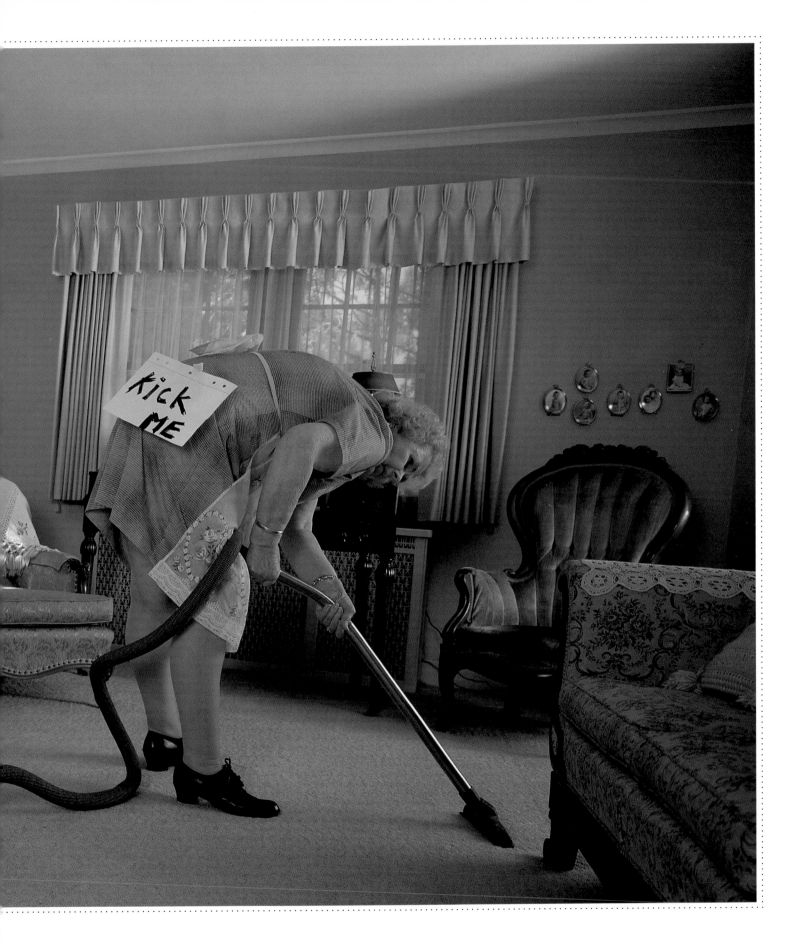

Laundry
Promise

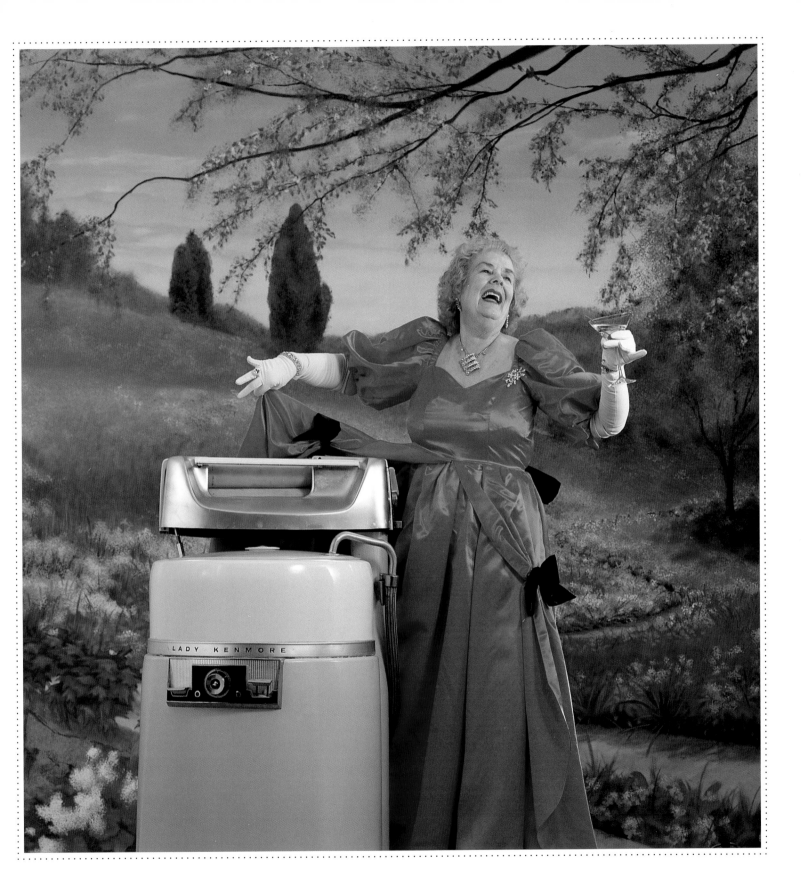

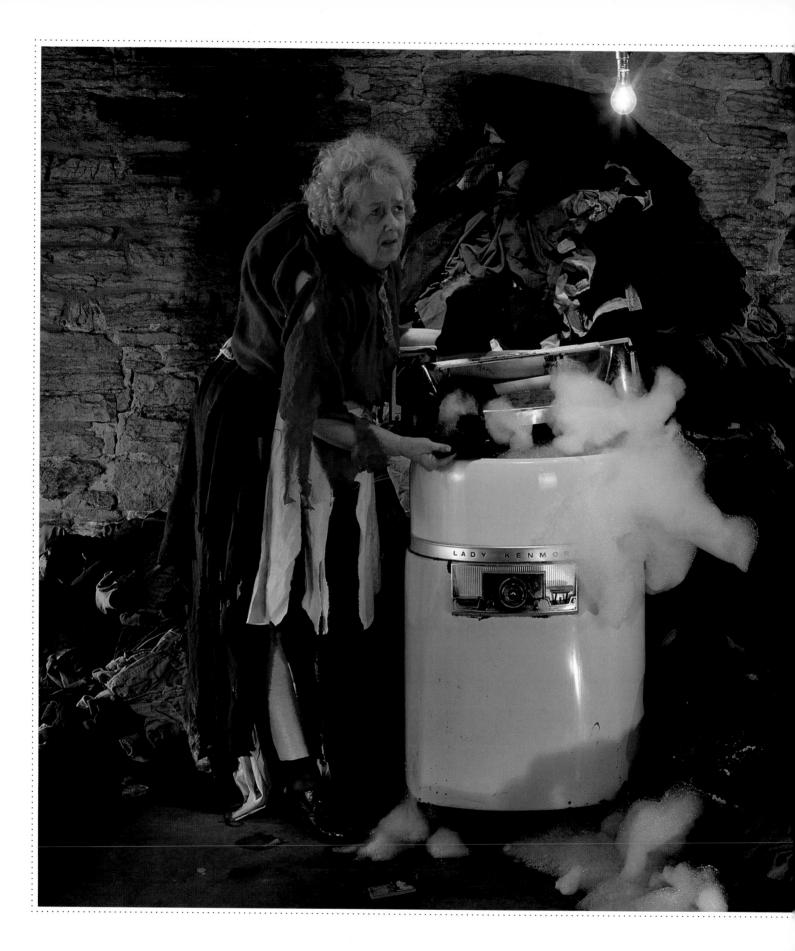

Laundry
Reality

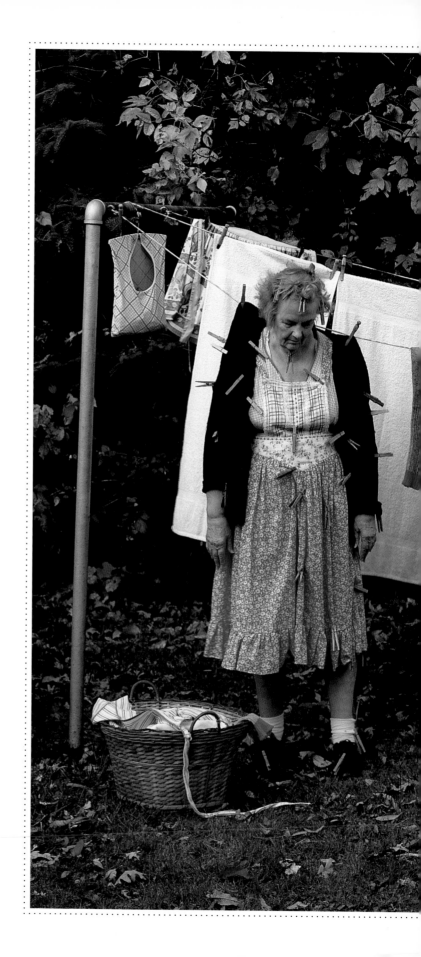

Out
to Dry

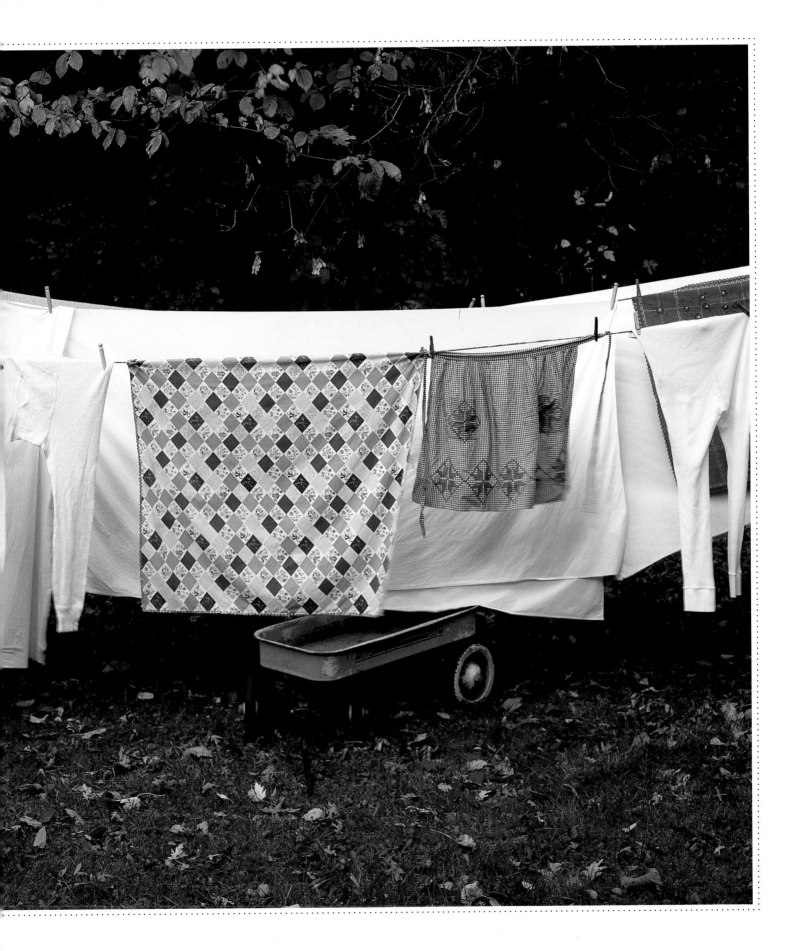

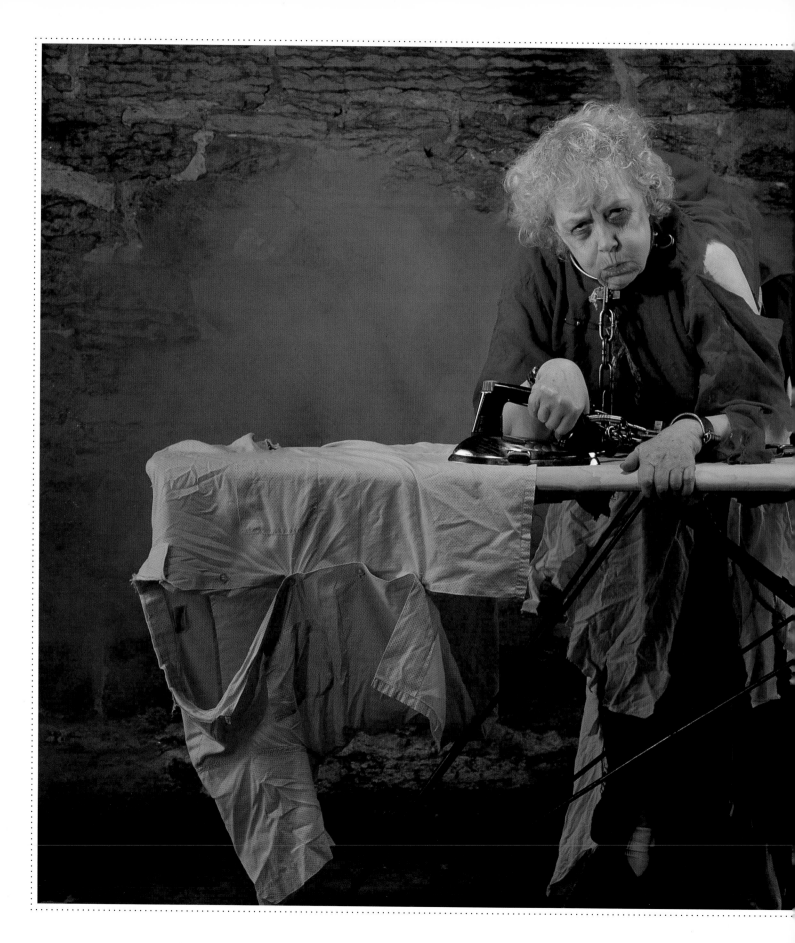

100%
Cotton

Mother's
Epiphany

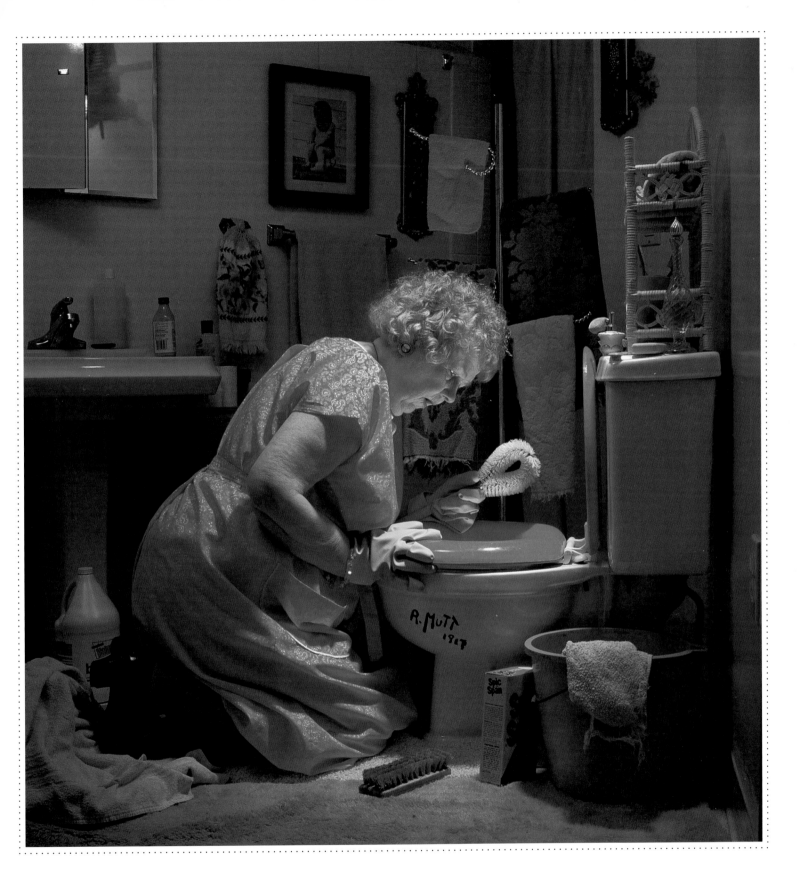

Mother Puts on
a Happy Face

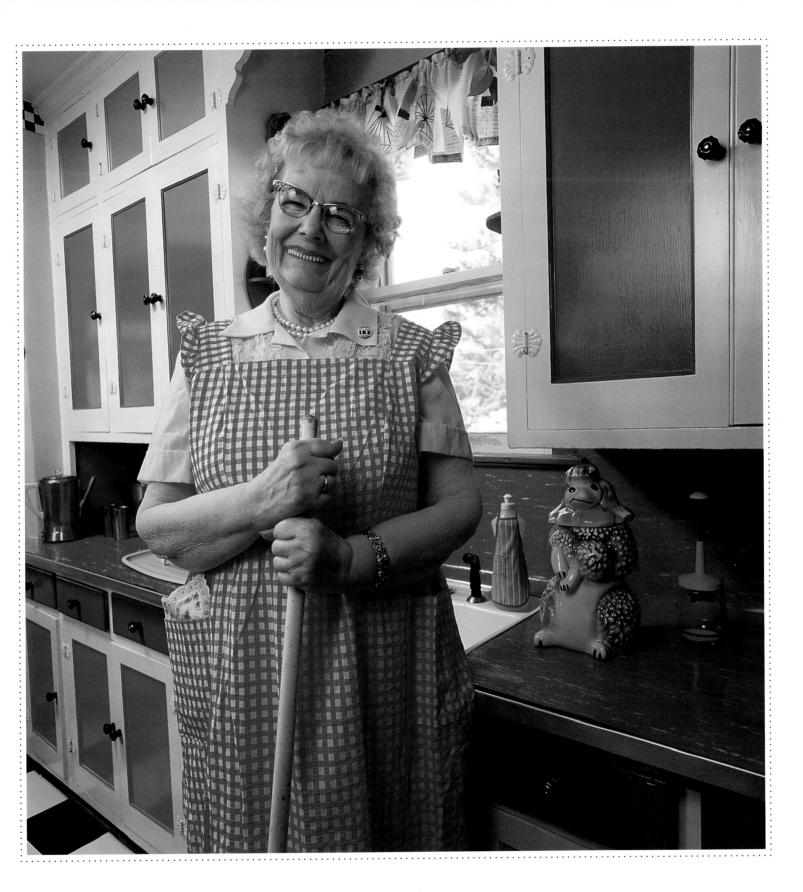

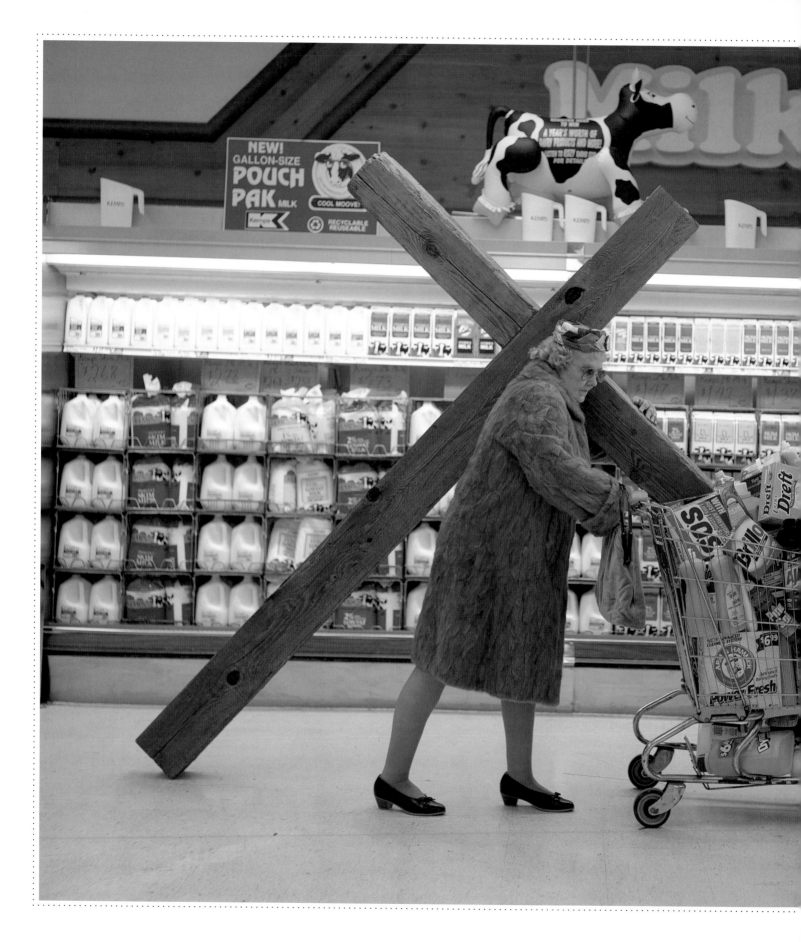

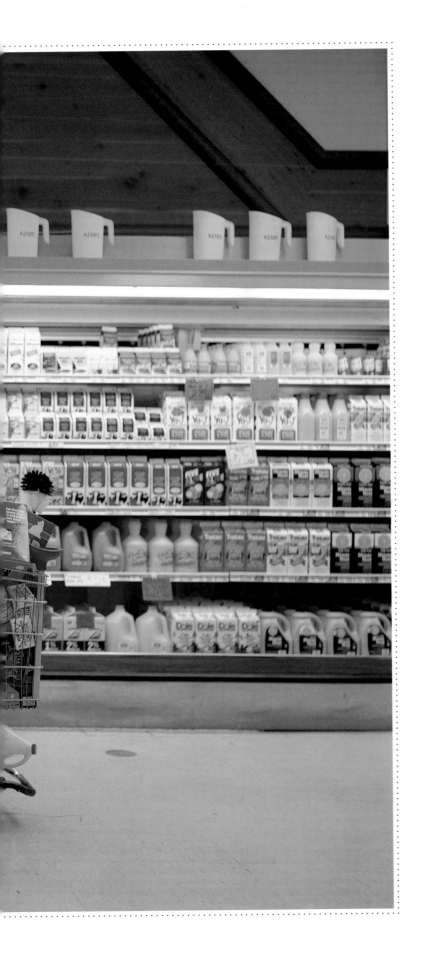

Mother Goes
to Market

Mother Under
Pressure
∽✥∽

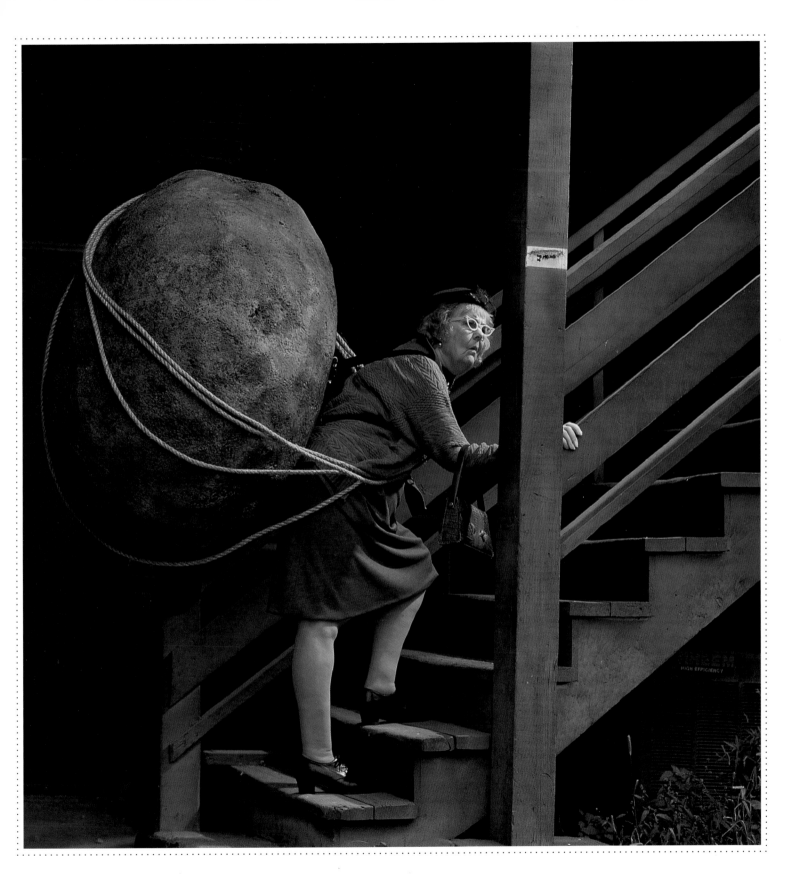

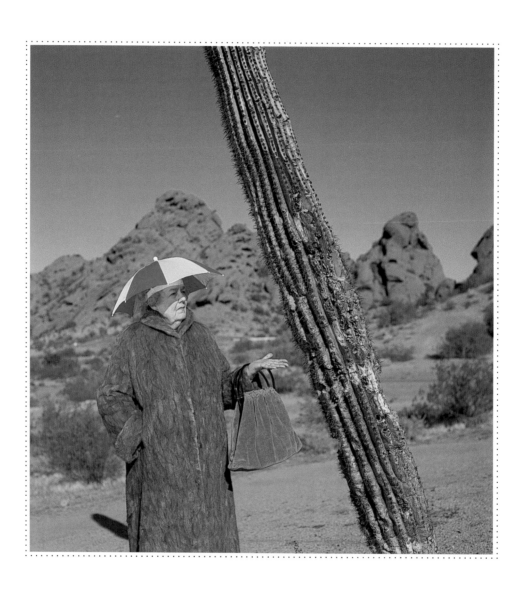

Always
Prepared

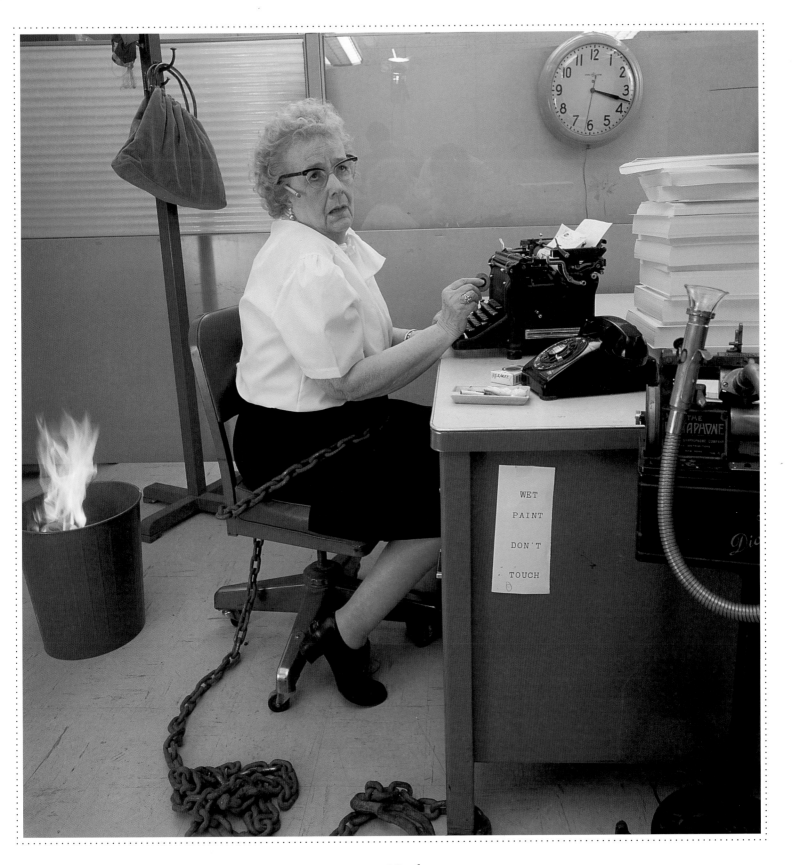

Mother as
Working Girl

Mommy
Deer

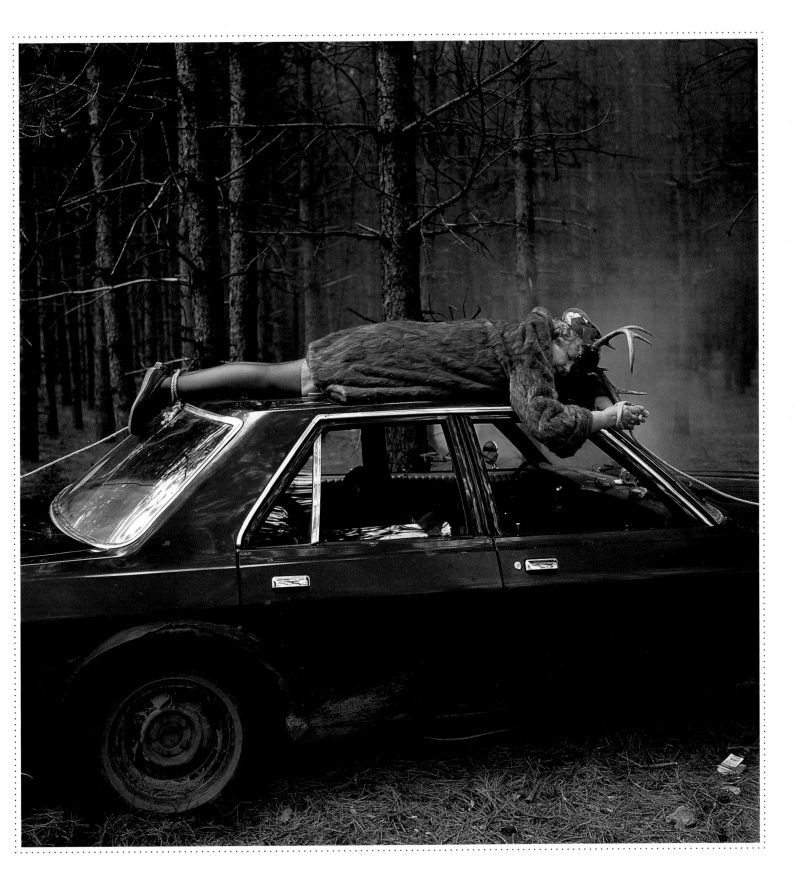

Mother as
Roadkill

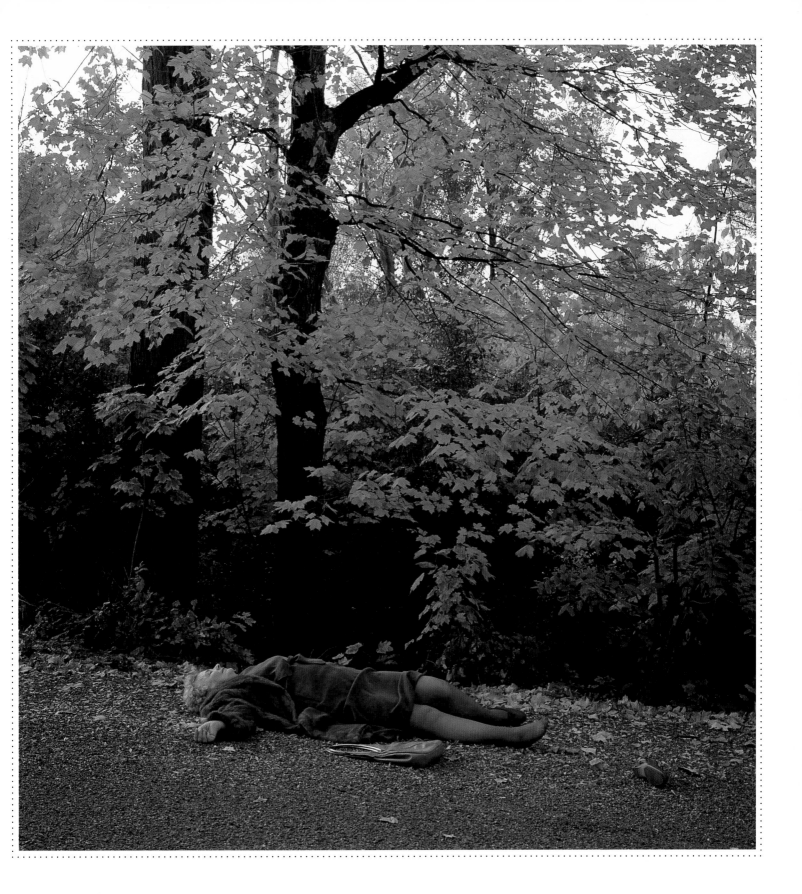

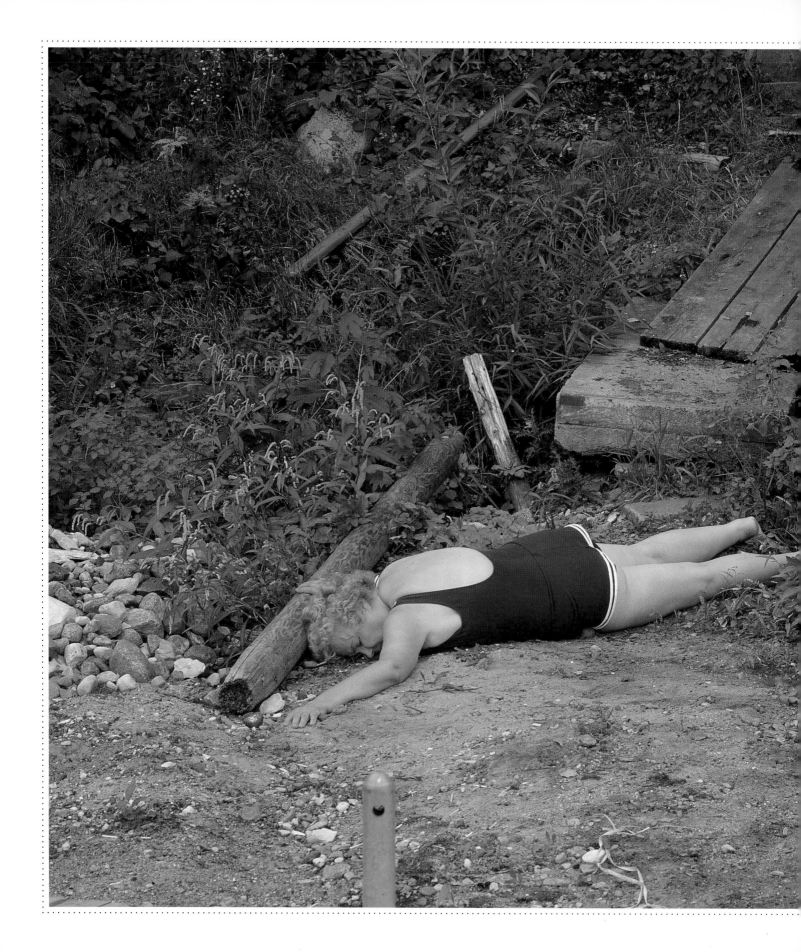

Mother as
 Driftwood

Mother's
Nature

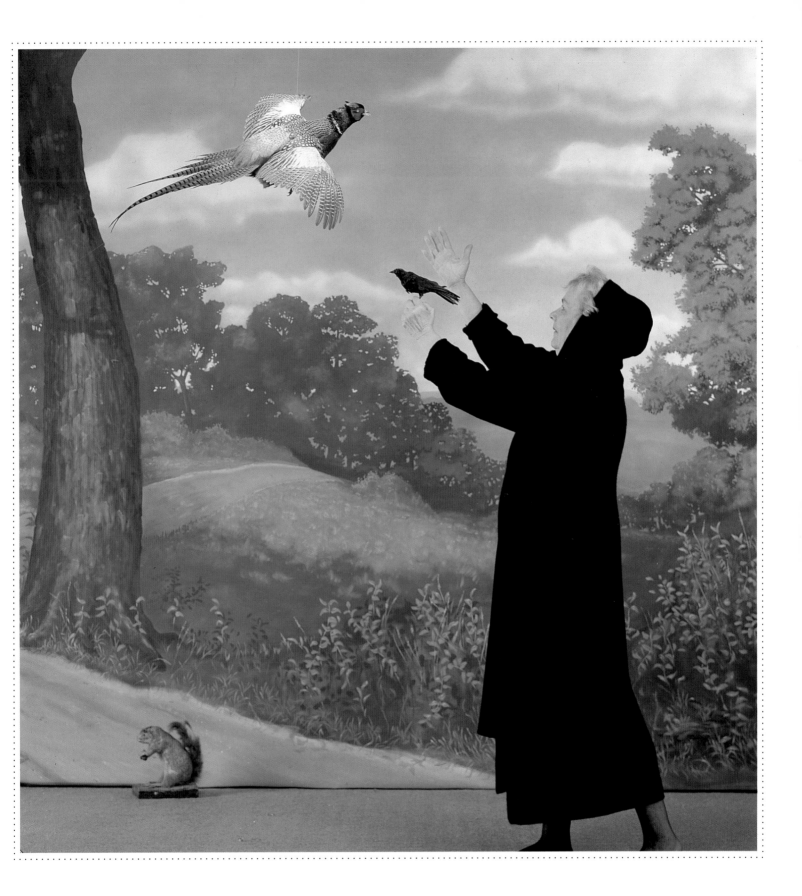

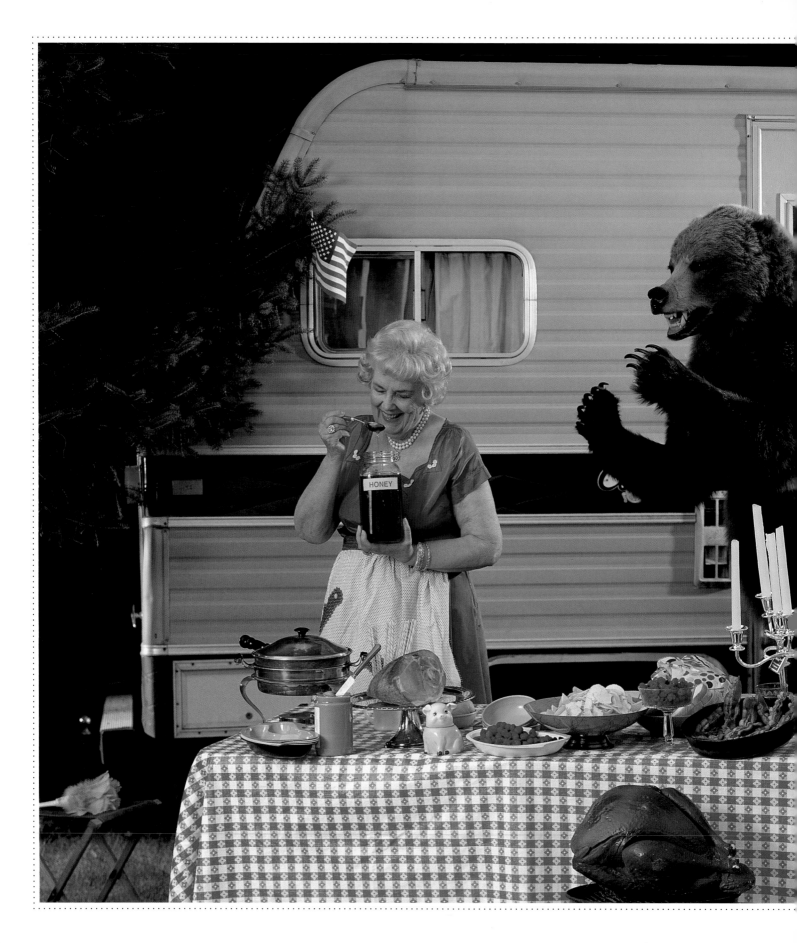

Mother at
Yellowstone

Mother as
Coffee Table

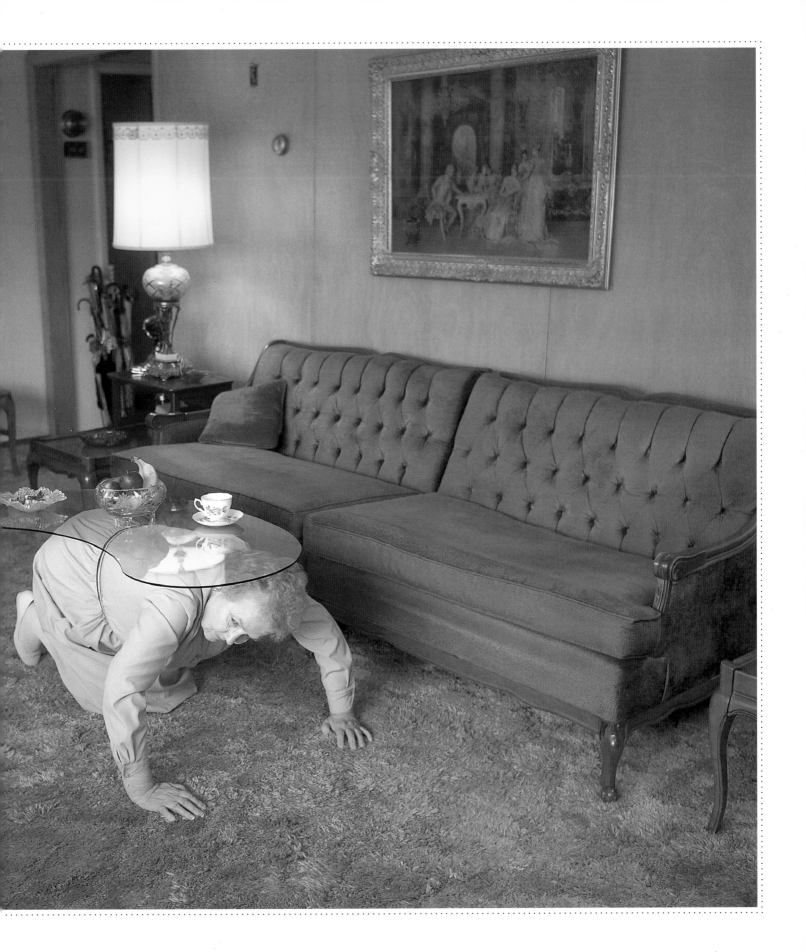

Mother in
Camouflage

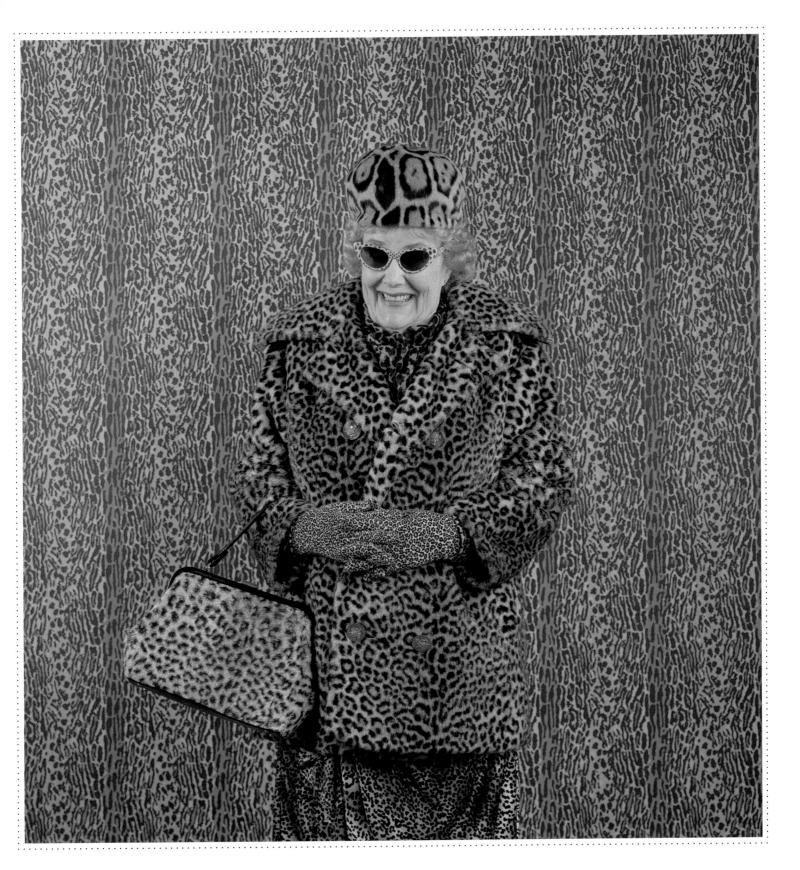

Mother Celebrates
Independence Day

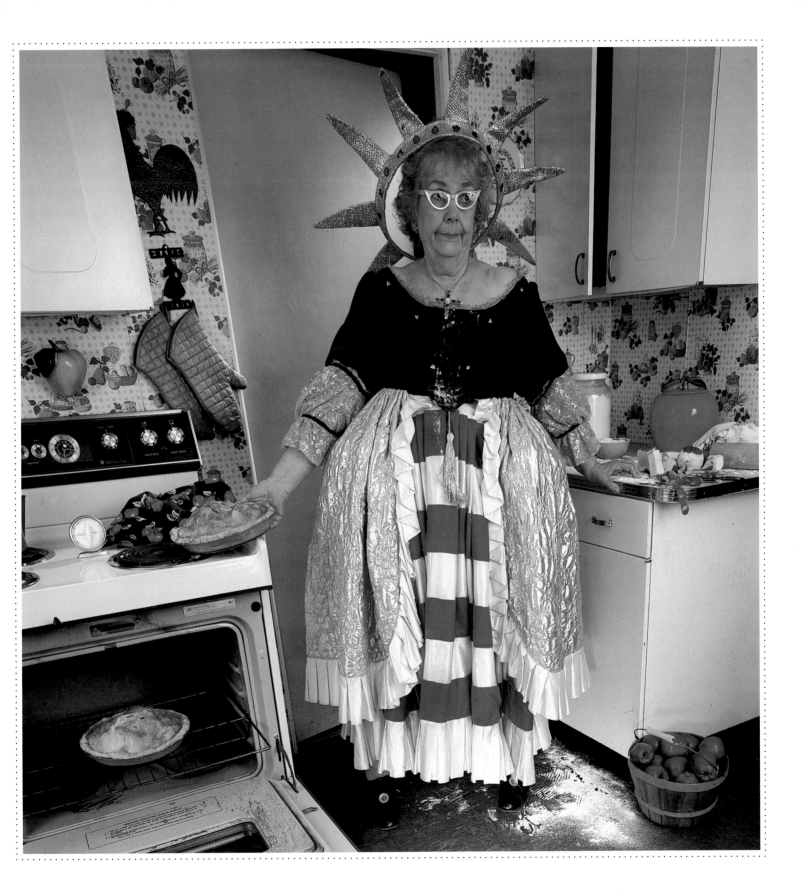

Mother's Little
Helpers

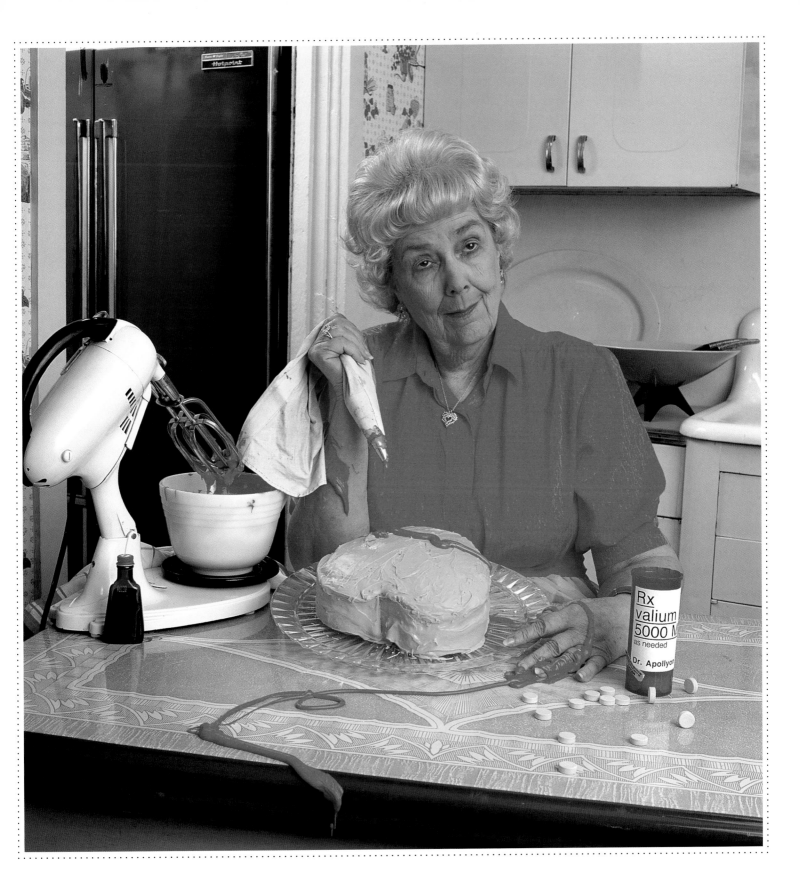

Mother Paints
The Last Supper

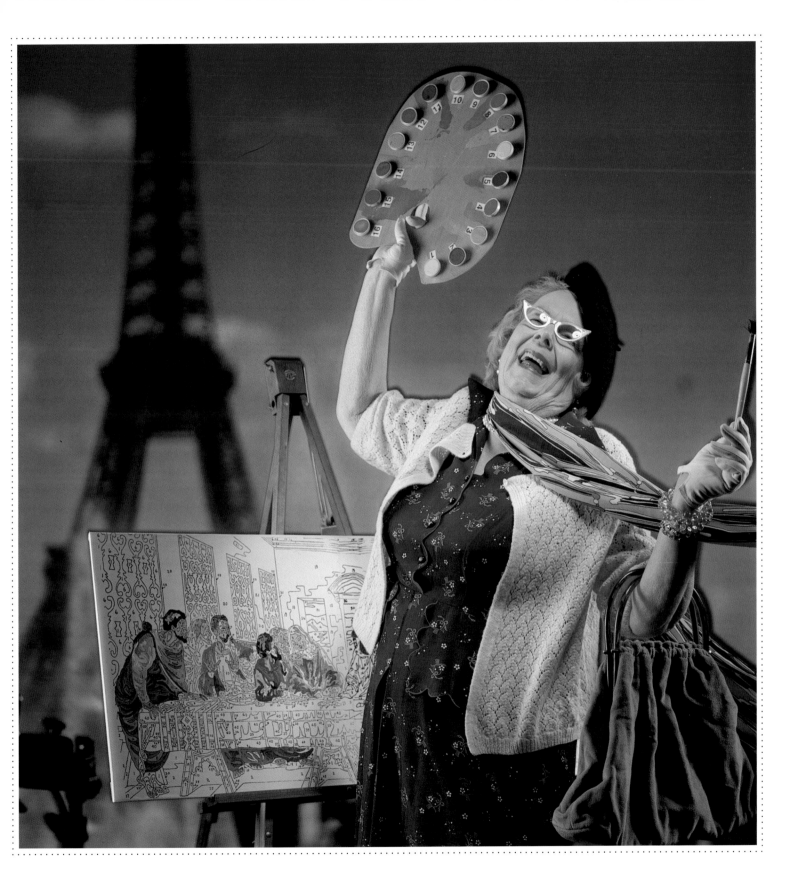

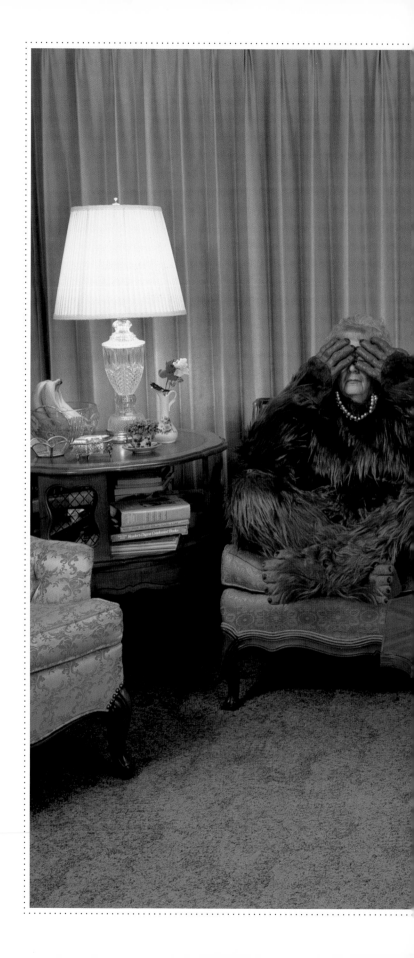

Keeper of the
Family Secrets

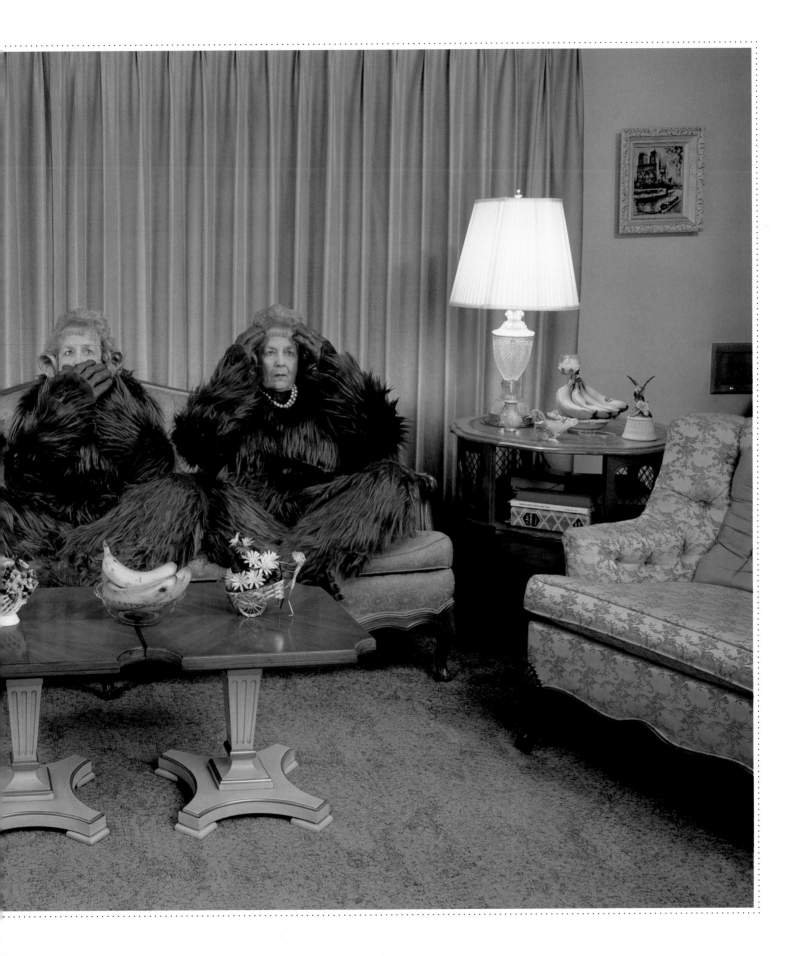

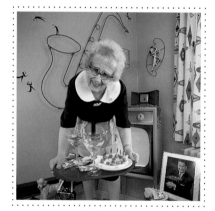

Mother as
Enabler

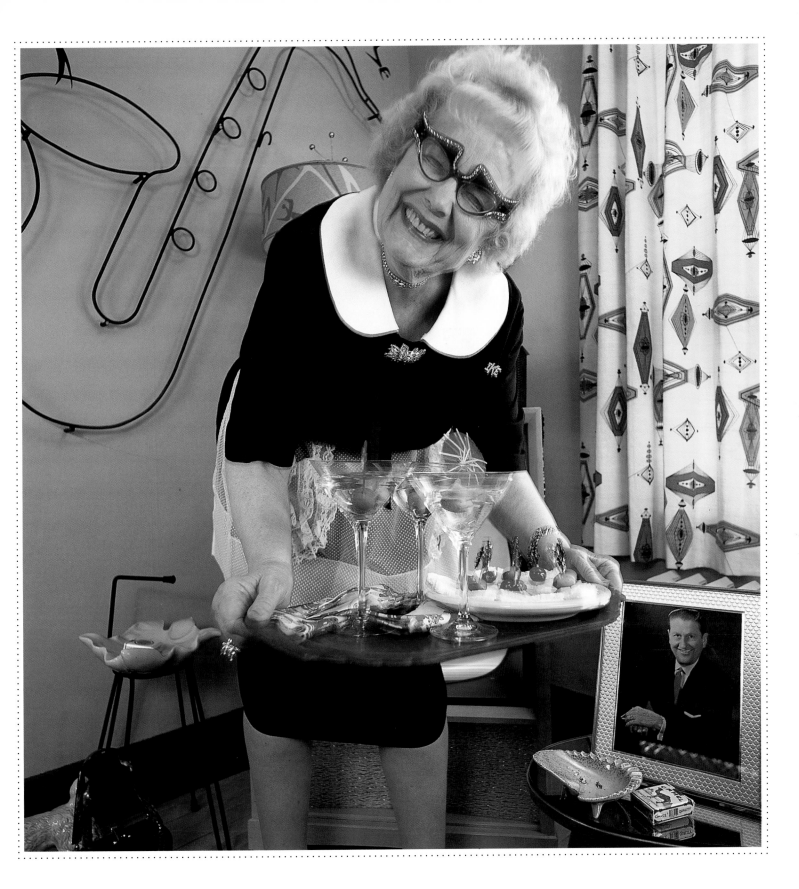

Mother Gets
Permed
ᴗ☙ᴗ

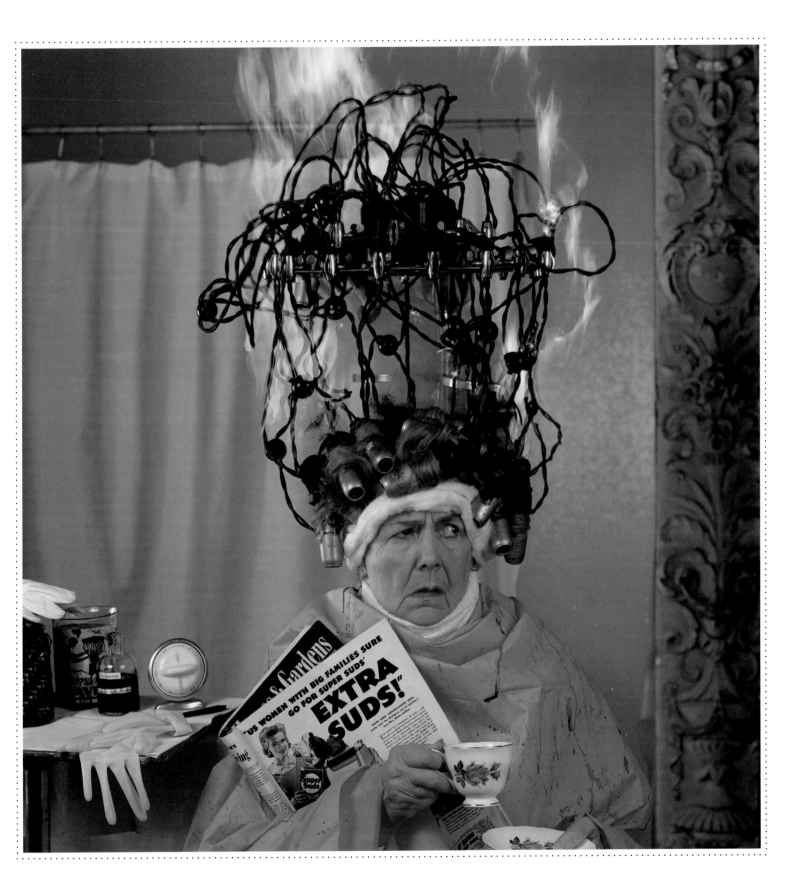

After
the Perm

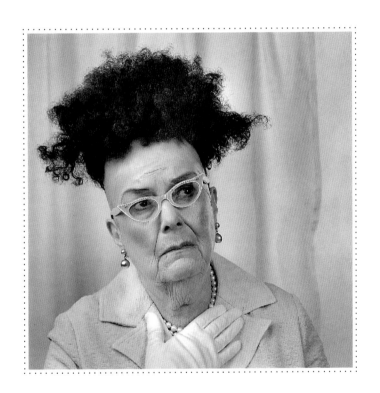

Life
Sentence

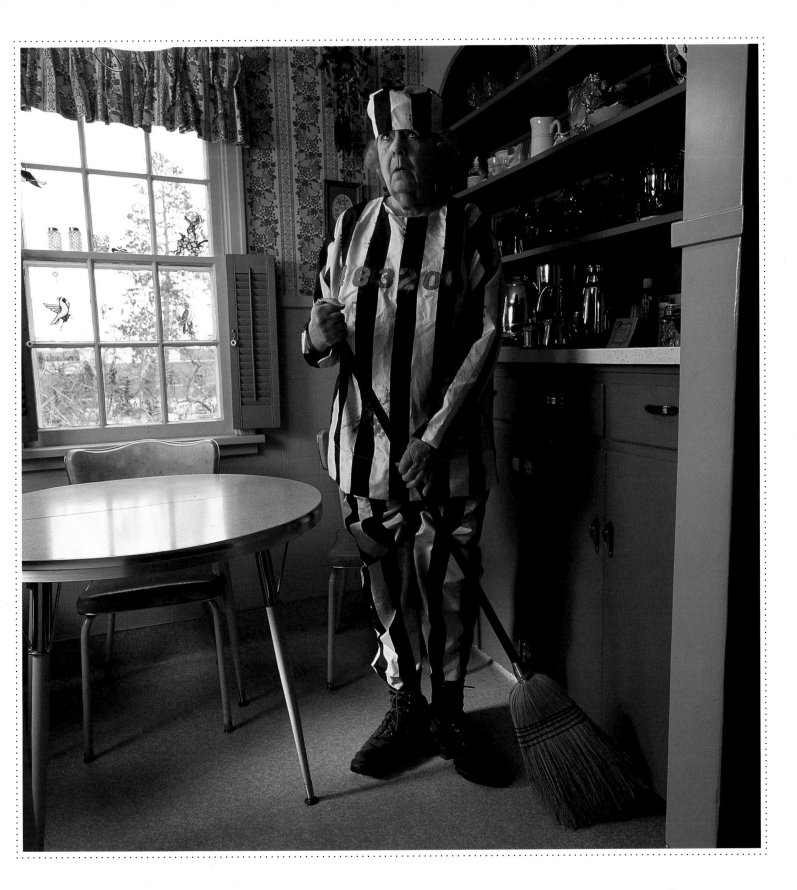

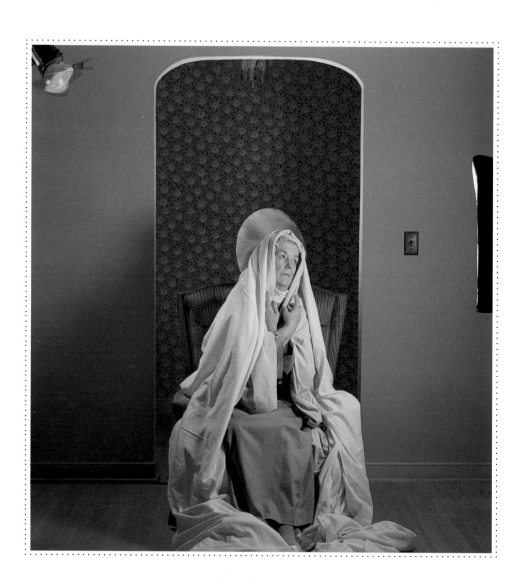

Mother as
Madonna

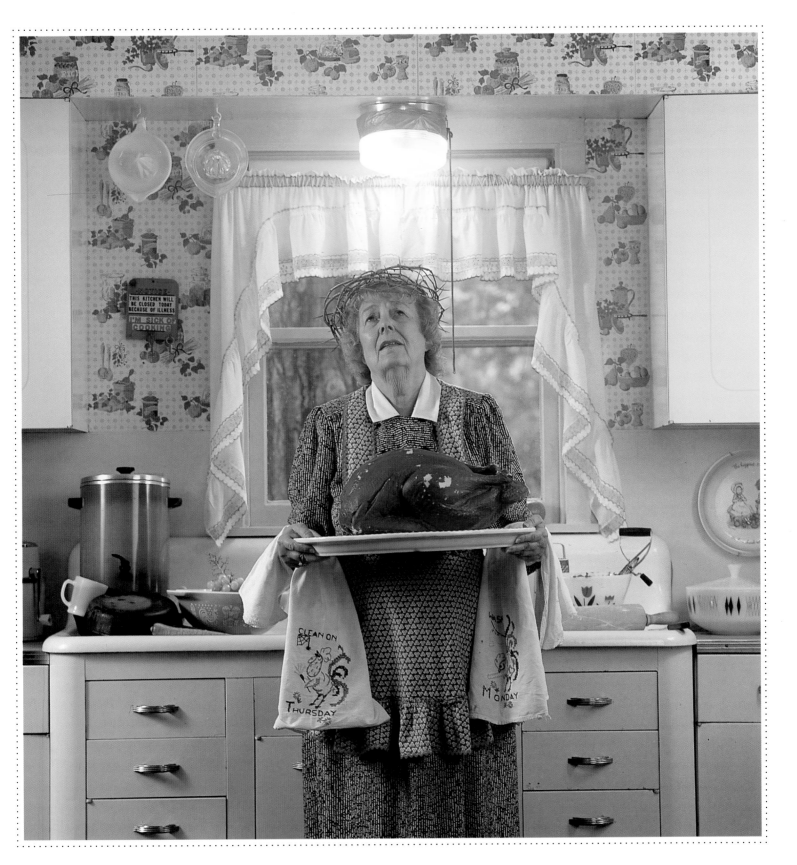

Mother with Thorns
and Turkey

Mother, Early
Sunday Morning

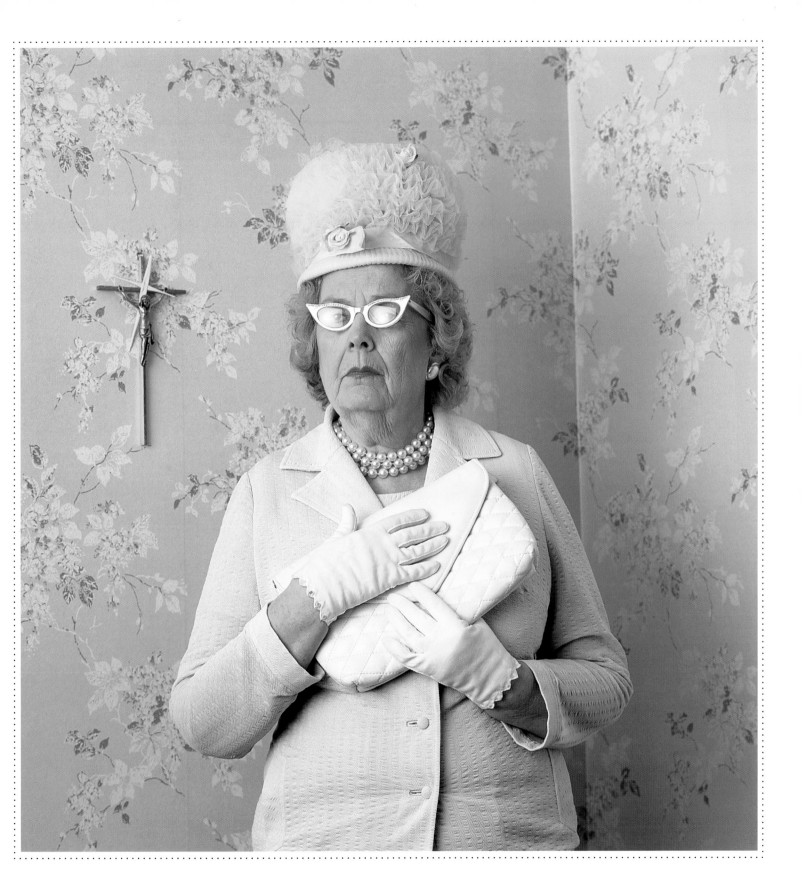

Sunday Afternoon
Surprise

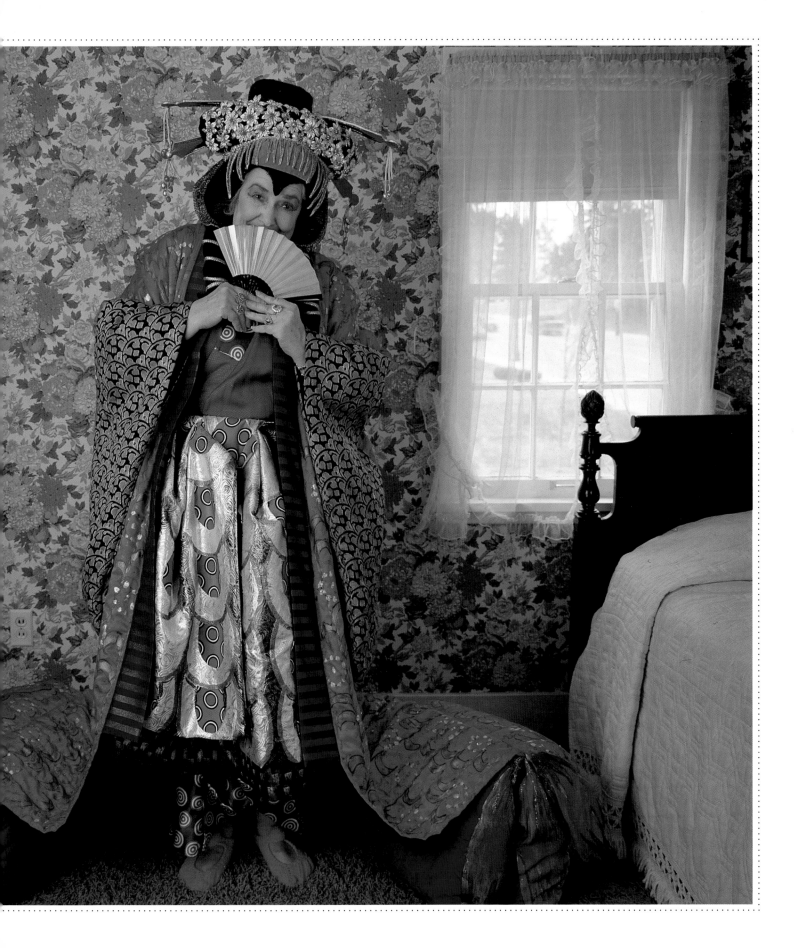

Return
to Sender

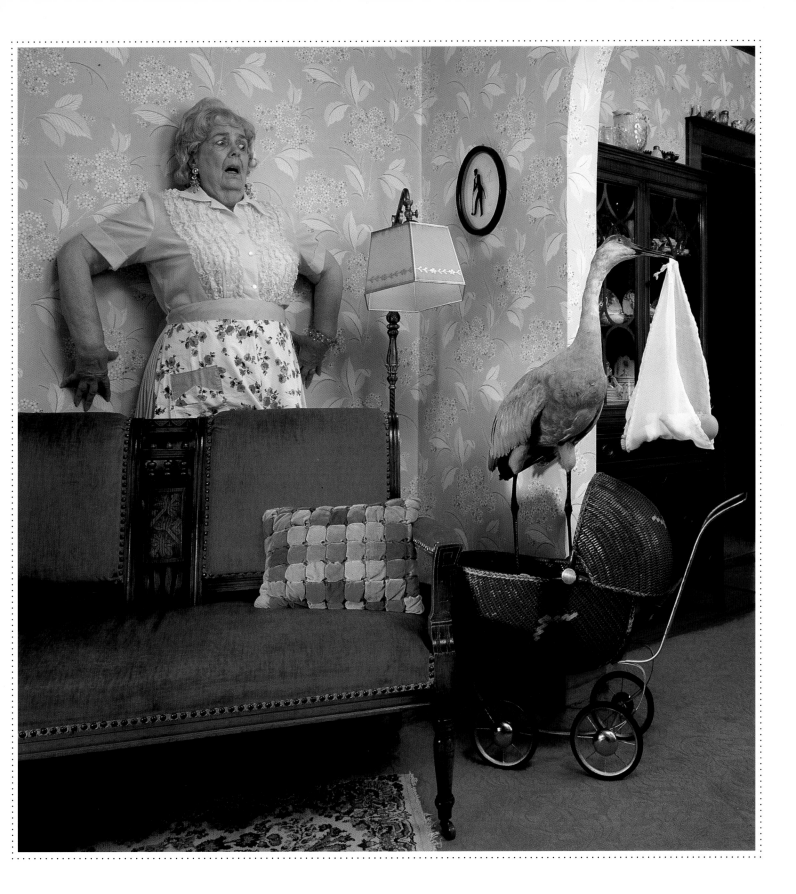

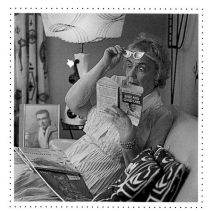

Shocked
by Spock

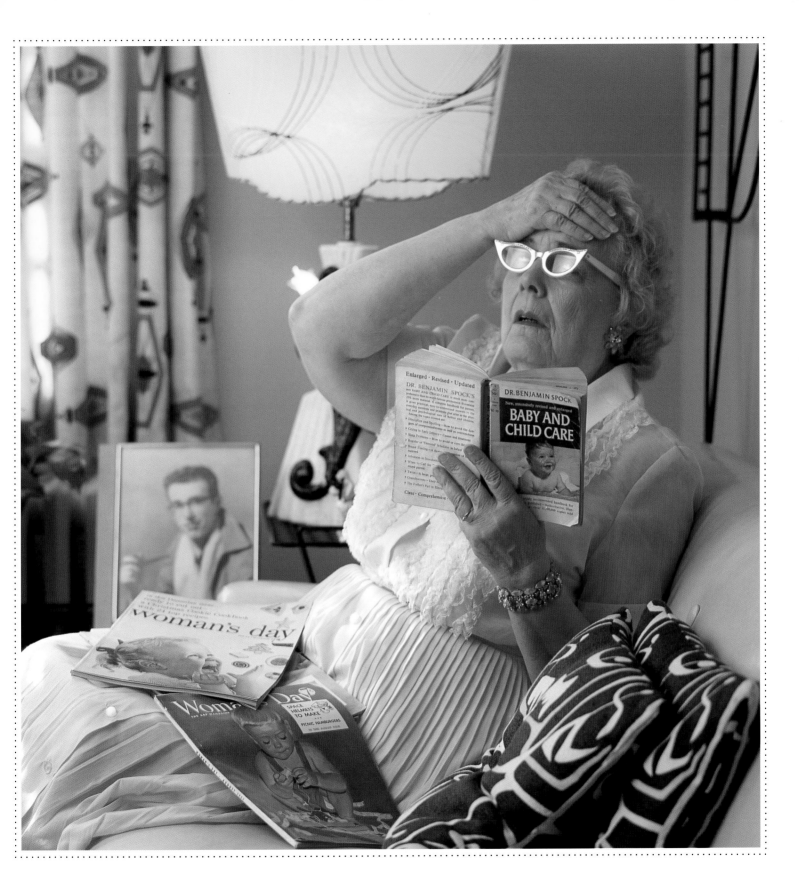

Don't
Look Back

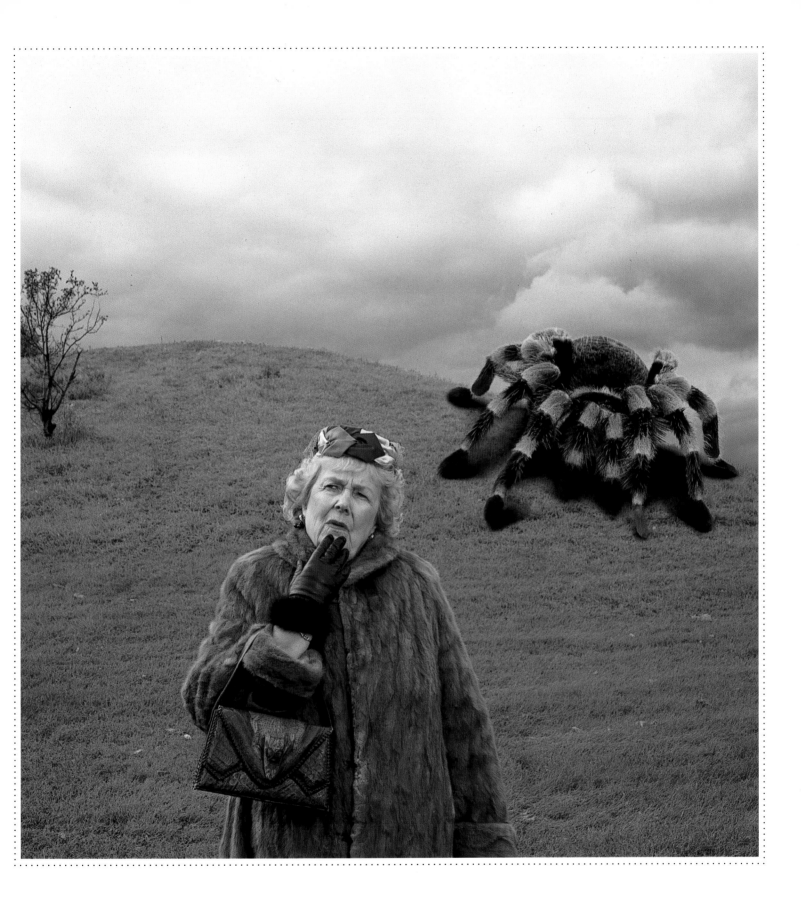

White
Death

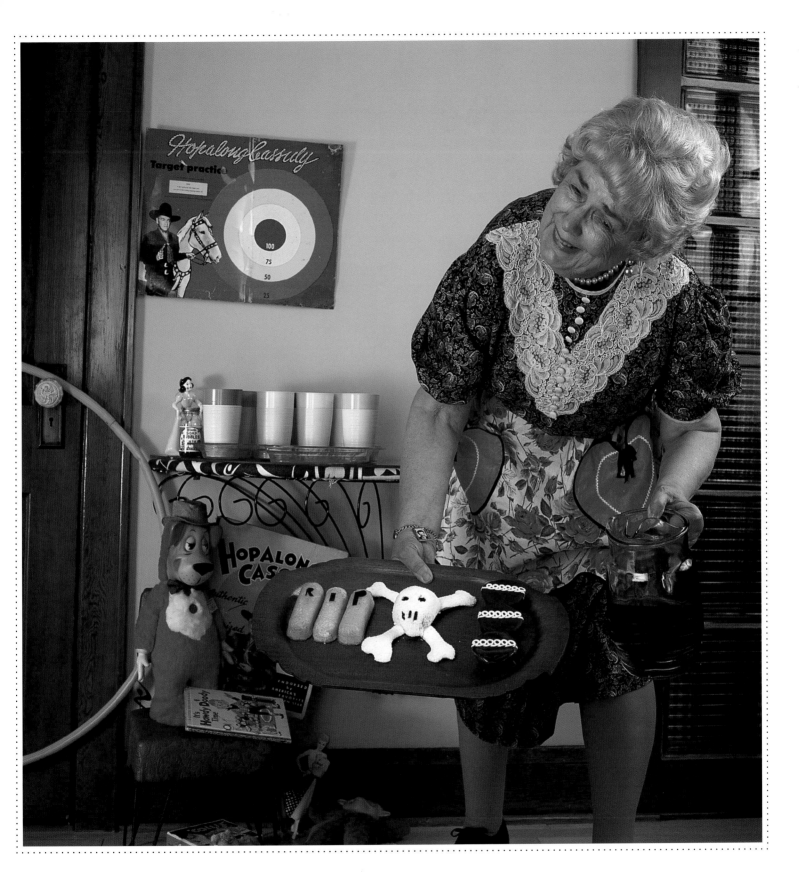

Mother Loses
Her Chips

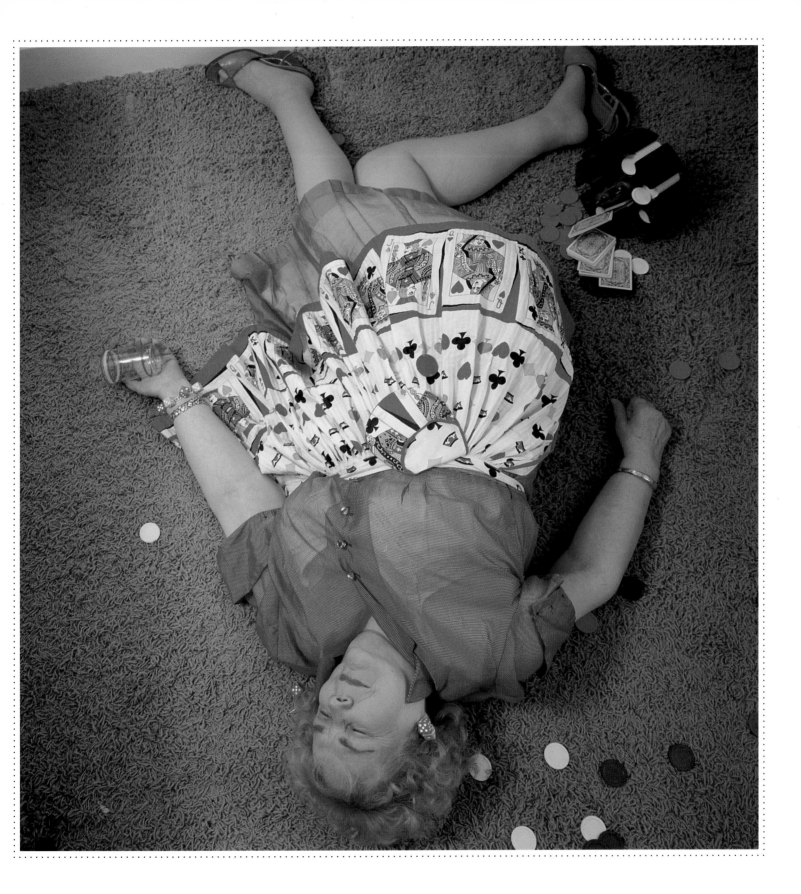

Mother
Reflects

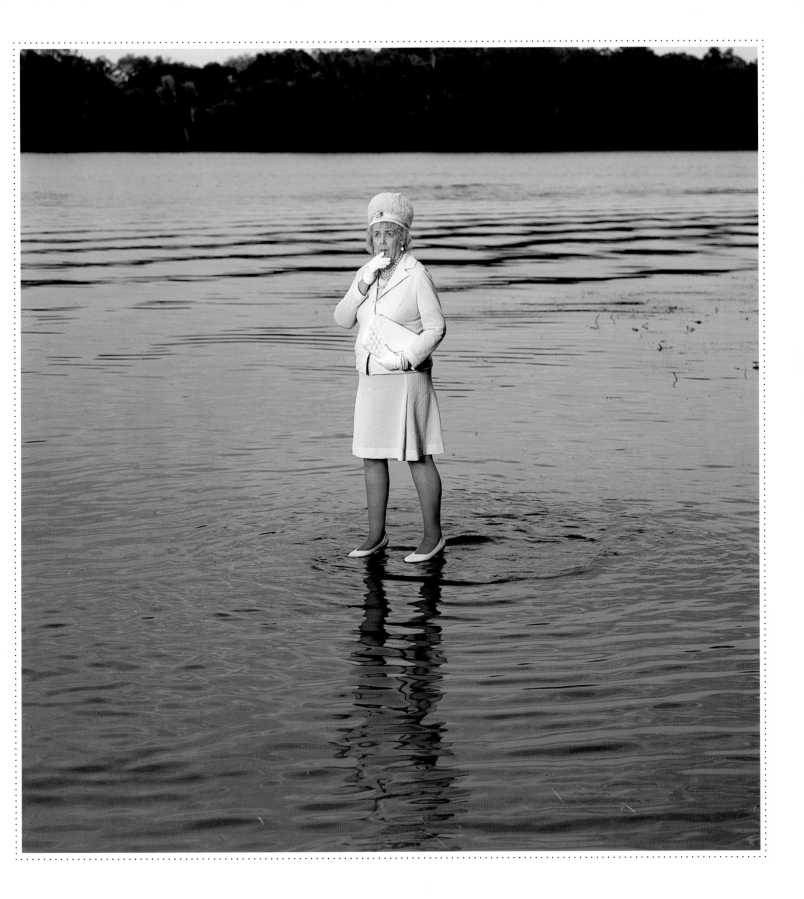

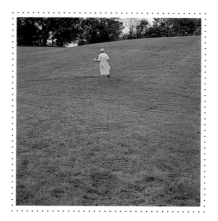

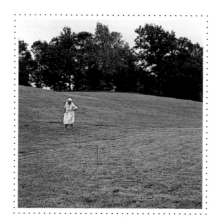

Mother Going
Nowhere

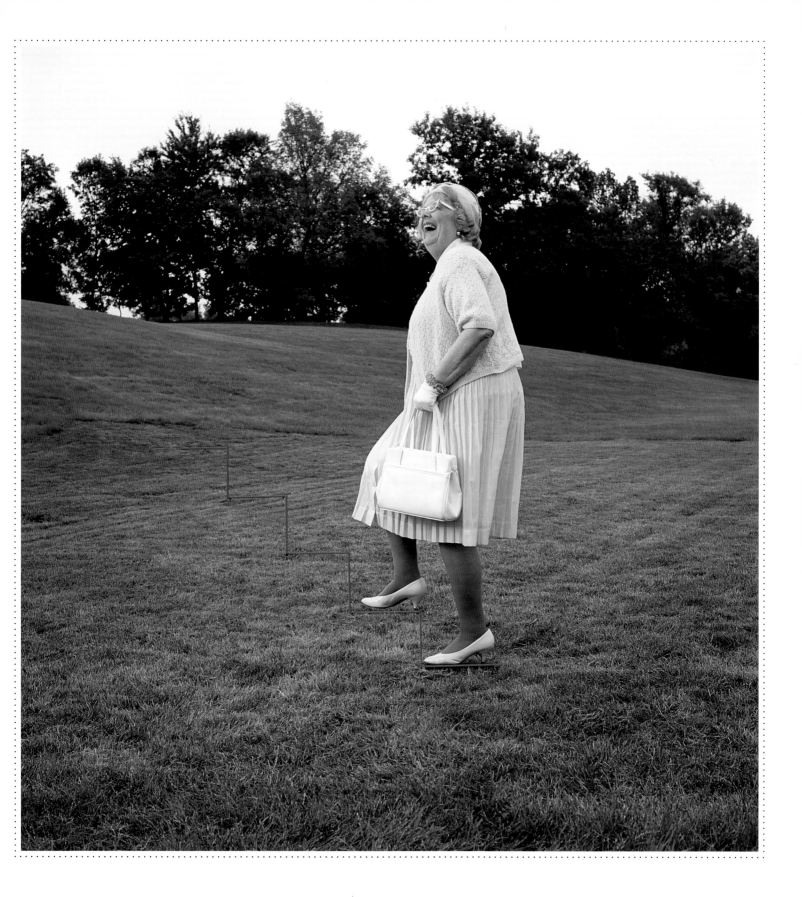

Mother as
Angel

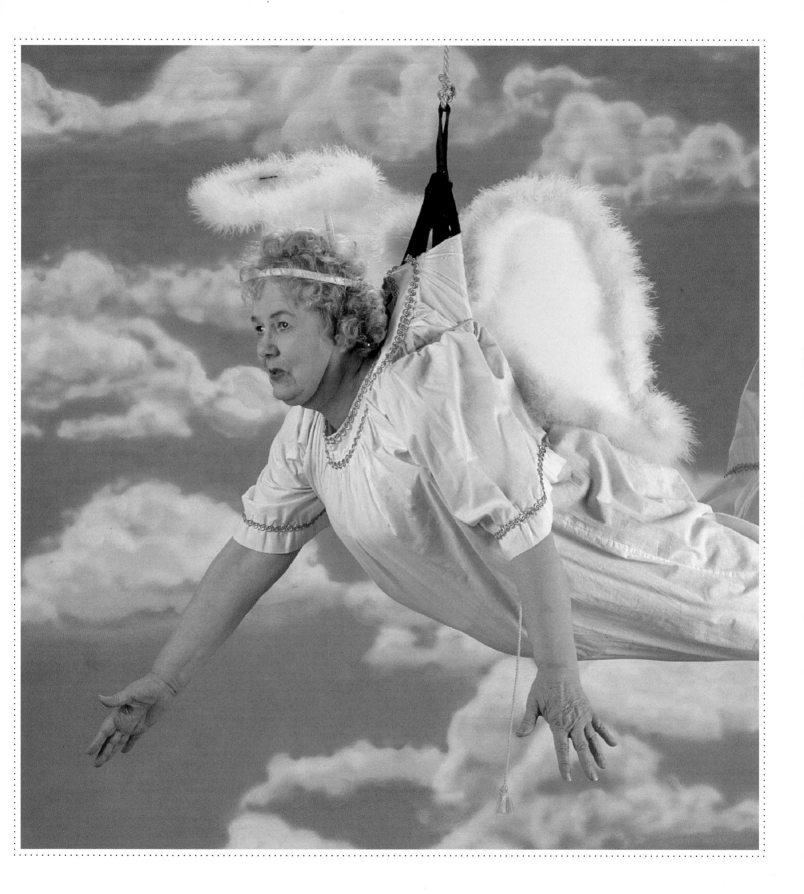

I

OWE MY GREATEST DEBT TO TWO VERY IMPORTANT CONTRIBUTORS TO THIS BOOK. THE FIRST IS MY MOTHER, VIVIAN, WHO SERVED AS MY SOLE MODEL.

Her sweet disposition, upbeat personality and wide range of expressions made this collection of photographs possible. Through every ordeal, she was always cheerful and smiling. I am very grateful for the time that this project enabled me to spend with my mother over the last few years. Between takes or in a hotel after a shoot, we talked at great length about our family history. I learned facts about her life and my heritage that I never might have known otherwise. The second key to the success of this project was my husband, Brian Sundstrom, who spent countless hours as a part-time locations scout, second assistant, costume stylist, and project accountant. He lugged, dragged and schlepped what amounts to thousands of pounds of equipment, props, costumes, and other minutiae for this book. I don't know of a more stable and selfless person than my husband. I am also endlessly grateful to my sister-in-law, Cathy Olausen, who drove my mother to shoots from ten to hundreds of miles away, supervised costume changes, and ensured that she was safe and comfortable at all times. I am greatly indebted to the talented and hardworking Karin Winegar, who found room in her busy schedule to write the introduction to this book. Sandra Nelson and Katherine Ella of Sandra Nelson Advertising offered invaluable assistance with the captions, as did Chris Vice, Susan Reed and Sandy Bucholtz. The following provided props and general encouragement: Dick Atlas, Naomi Austin, William J. Birkett, John Bauer, Sue Dietrich, Peter Moore, Rodney Schwartz, Ed Noreen, Lee Waldon, and Scornovacco Antiques. Ellen Sundstrom and Dan Malenus at LensCrafters repaired much of the vintage eyewear in the photographs. Phil James lent some specialized photographic equipment. Judy Trest helped me organize a focus group, which allowed me to reflect on the entire project with a more critical eye. Harvey Mackay offered his advice and encouragement throughout this long project. And author John Louis Anderson gave me many "'attagirl,' stick to it" talks during those times that money for this project was flying out the window faster than a speeding bullet. I thank Scott Edelstein, Deborah Kass Orenstein, Jonathon Lazear, Dennis Cass, and Leslee Avchen for their excellent advice and counsel. I hired location scouts so that each room Mother was depicted in would provide a sense of history. One very special location was Jere Sears' house, used in "White Death," "Mother Puts on a Happy Face," "Shocked by Spock," and "Mother as Enabler." Another distinctive house was Cecilia Wilcox's, found for me by Paul Olson and Sandy Layman and used in "Life Sentence," "Mother as Kitty Valet," "Attack of the Rug Rats," and "Sunday Afternoon Surprise." Thanks also, to the Ogle family for giving our crew free run of their supermarket, shown in "Mother Goes to Market." ProColor was responsible for all the processing and computer work on the photographs in this book: John Schueller and Michelle Quade supervised the processing, Matt Case and Dan Crawford created the dupes, and Doug Meisner and Sue Mann performed the fantastic computer work. I am forever grateful to Dr. Smith Schuneman, founder of the photojournalism program at the University of Minnesota. His guidance changed my life and taught me that anything is possible. Thank you to the publisher of Penguin Studio, Michael Fragnito; my editor, Sarah Scheffel; and my publicist, Meg Lenihan, for their guidance and hard work. And last, but not least, thanks to Michael Bierut and Esther Bridavsky of Pentagram for their stunning design. —*Judy Olausen*